PENGUIN BOOKS — GREAT IDEAS

On Art and Life

John Ruskin
1819–1900

John Ruskin

On Art and Life

PENGUIN BOOKS — GREAT IDEAS

PENGUIN BOOKS

Published by the Penguin Group

Penguin Group (USA) Inc., 375 Hudson Street, New York, New York 10014, U.S.A.
Penguin Group (Canada), 90 Eglinton Avenue East, Suite 700, Toronto, Ontario, Canada
M4P 2Y3 (a division of Pearson Penguin Canada Inc.)
Penguin Books Ltd, 80 Strand, London WC2R 0RL, England
Penguin Ireland, 25 St Stephen's Green, Dublin 2, Ireland (a division of Penguin Books Ltd)
Penguin Group (Australia), 250 Camberwell Road, Camberwell,
Victoria 3124, Australia (a division of Pearson Australia Group Pty Ltd)
Penguin Books India Pvt Ltd, 11 Community Centre,
Panchsheel Park, New Delhi – 110 017, India
Penguin Group (NZ), cnr Airborne and Rosedale Roads, Albany, Auckland 1310, New
Zealand (a division of Pearson New Zealand Ltd)
Penguin Books (South Africa) (Pty) Ltd, 24 Sturdee Avenue,
Rosebank, Johannesburg 2196, South Africa

Penguin Books Ltd, Registered Offices:
80 Strand, London WC2R 0RL, England

"The Nature of Gothic" first published in *The Stones of Venice*, Vol. 2, 1853
"The Work of Iron, in Nature, Art, and Policy" first published in *The Two Paths* 1859
Published in Penguin Books (U.K.) 2004
First published in the United States of America by Penguin Books 2005

1 3 5 7 9 10 8 6 4 2

Taken from the Penguin Classic edition *Unto This Last and Other Writings*,
edited and introduced by Clive Wilmer

LIBRARY OF CONGRESS CATALOGING IN PUBLICATION DATA
Ruskin, John, 1819–1900.
[Nature of Gothic]
On art and life / John Ruskin.
p. cm.—(Great ideas)
Works originally published 1853–1859.
Contents: The nature of Gothic—The work of iron.
ISBN 0 14 30.3628 9
1. Art. I. Ruskin, John, 1819–1900. Work of iron. II. Title. III. Series.
N7445.2.R793 2005
709—dc22 2005047447

Printed in the United States of America
Set in Monotype Dante

Contents

The Nature of Gothic

IF the reader will look back to the division of our subject which was made in the first chapter of the first volume,[*] he will find that we are now about to enter upon the examination of that school of Venetian architecture which forms an intermediate step between the Byzantine and Gothic forms; but which I find may be conveniently considered in its connexion with the latter style. In order that we may discern the tendency of each step of this change, it will be wise in the outset to endeavour to form some general idea of its final result. We know already what the Byzantine architecture is from which the transition was made, but we ought to know something of the Gothic architecture into which it led. I shall endeavour therefore to give the reader in this chapter an idea, at once broad and definite, of the true nature of *Gothic* architecture, properly so called; not of that of Venice only, but of universal Gothic: for it will be one of the most interesting parts of our subsequent inquiry to find out how far Venetian architecture reached the universal or perfect type of Gothic, and how far it either fell short of it, or assumed foreign and independent forms.

The principal difficulty in doing this arises from the

[*] i.e., of *The Stones of Venice*.

fact that every building of the Gothic period differs in some important respect from every other; and many include features which, if they occurred in other buildings, would not be considered Gothic at all; so that all we have to reason upon is merely, if I may be allowed so to express it, a greater or less degree of *Gothicness* in each building we examine. And it is this Gothicness, – the character which, according as it is found more or less in a building, makes it more or less Gothic, – of which I want to define the nature; and I feel the same kind of difficulty in doing so which would be encountered by any one who undertook to explain, for instance, the nature of Redness, without any actually red thing to point to, but only orange and purple things. Suppose he had only a piece of heather and a dead oak-leaf to do it with. He might say, the colour which is mixed with the yellow in this oak-leaf, and with the blue in this heather, would be red, if you had it separate; but it would be difficult, nevertheless, to make the abstraction perfectly intelligible; and it is so in a far greater degree to make the abstraction of the Gothic character intelligible, because that character itself is made up of many mingled ideas, and can consist only in their union. That is to say, pointed arches do not constitute Gothic, nor vaulted roofs, nor flying buttresses, nor grotesque sculptures; but all or some of these things, and many other things with them, when they come together so as to have life.

Observe also, that, in the definition proposed, I shall only endeavour to analyze the idea which I suppose already to exist in the reader's mind. We all have some notion, most of us a very determined one, of the meaning

of the term Gothic, but I know that many persons have this idea in their minds without being able to define it: that is to say, understanding generally that Westminster Abbey is Gothic, and St Paul's is not, that Strasburg Cathedral is Gothic, and St Peter's is not, they have, nevertheless, no clear notion of what it is that they recognize in the one or miss in the other, such as would enable them to say how far the work at Westminster or Strasburg is good and pure of its kind; still less to say of any nondescript building, like St James's Palace or Windsor Castle, how much right Gothic element there is in it, and how much wanting. And I believe this inquiry to be a pleasant and profitable one; and that there will be found something more than usually interesting in tracing out this grey, shadowy, many-pinnacled image of the Gothic spirit within us; and discerning what fellowship there is between it and our Northern hearts. And if, at any point of the inquiry, I should interfere with any of the reader's previously formed conceptions, and use the term Gothic in any sense which he would not willingly attach to it, I do not ask him to accept, but only to examine and understand, my interpretation, as necessary to the intelligibility of what follows in the rest of the work.

We have, then, the Gothic character submitted to our analysis, just as the rough mineral is submitted to that of the chemist, entangled with many other foreign substances, itself perhaps in no place pure, or ever to be obtained or seen in purity for more than an instant; but nevertheless a thing of definite and separate nature, however inextricable or confused in appearance. Now observe: the chemist defines his mineral by two separate

kinds of character; one external, its crystalline form, hardness, lustre, etc.; the other internal, the proportions and nature of its constituent atoms. Exactly in the same manner, we shall find that Gothic architecture has external forms and internal elements. Its elements are certain mental tendencies of the builders, legibly expressed in it; as fancifulness, love of variety, love of richness, and such others. Its external forms are pointed arches, vaulted roofs, etc. And unless both the elements and the forms are there, we have no right to call the style Gothic. It is not enough that it has the Form, if it have not also the power and life. It is not enough that it has the Power, if it have not the form. We must therefore inquire into each of these characters successively; and determine first, what is the Mental Expression, and secondly, what the Material Form of Gothic architecture, properly so called.

1st Mental Power of Expression. What characters, we have to discover, did the Gothic builders love, or instinctively express in their work, as distinguished from all other builders?

Let us go back for a moment to our chemistry, and note that, in defining a mineral by its constituent parts, it is not one nor another of them, that can make up the mineral, but the union of all: for instance, it is neither in charcoal, nor in oxygen, nor in lime, that there is the making of chalk, but in the combination of all three in certain measures; they are all found in very different things from chalk, and there is nothing like chalk either in charcoal or in oxygen, but they are nevertheless necessary to its existence.

So in the various mental characters which make up

4

the soul of Gothic. It is not one nor another that produces it; but their union in certain measures. Each one of them is found in many other architectures beside Gothic; but Gothic cannot exist where they are not found, or, at least, where their place is not in some way supplied. Only there is this great difference between the composition of the mineral and of the architectural style, that if we withdraw one of its elements from the stone, its form is utterly changed, and its existence as such and such a mineral is destroyed; but if we withdraw one of its mental elements from the Gothic style, it is only a little less Gothic than it was before, and the union of two or three of its elements is enough already to bestow a certain Gothicness of character, which gains in intensity as we add the others, and loses as we again withdraw them.

I believe, then, that the characteristic or moral elements of Gothic are the following, placed in the order of their importance:

1. Savageness.
2. Changefulness.
3. Naturalism.
4. Grotesqueness.
5. Rigidity.
6. Redundance.

These characters are here expressed as belonging to the building; as belonging to the builder, they would be expressed thus: – 1. Savageness or Rudeness. 2. Love of Change. 3. Love of Nature. 4. Disturbed Imagination. 5. Obstinacy. 6. Generosity. And I repeat, that the

withdrawal of any one, or any two, will not at once destroy the Gothic character of a building, but the removal of a majority of them will. I shall proceed to examine them in their order.

SAVAGENESS. I am not sure when the word 'Gothic' was first generically applied to the architecture of the North; but I presume that, whatever the date of its original usage, it was intended to imply reproach, and express the barbaric character of the nations among whom that architecture arose. It never implied that they were literally of Gothic lineage, far less that their architecture had been originally invented by the Goths themselves; but it did imply that they and their buildings together exhibited a degree of sternness and rudeness, which, in contradistinction to the character of Southern and Eastern nations, appeared like a perpetual reflection of the contrast between the Goth and the Roman in their first encounter. And when that fallen Roman, in the utmost impotence of his luxury, and insolence of his guilt, became the model for the imitation of civilized Europe, at the close of the so-called Dark ages, the word Gothic became a term of unmitigated contempt, not unmixed with aversion. From that contempt, by the exertion of the antiquaries and architects of this century, Gothic architecture has been sufficiently vindicated; and perhaps some among us, in our admiration of the magnificent science of its structure, and sacredness of its expression, might desire that the term of ancient reproach should be withdrawn, and some other, of more apparent honourableness, adopted in its place. There is no chance, as there is no need, of such a substitution. As

far as the epithet was used scornfully, it was used falsely; but there is no reproach in the word, rightly understood; on the contrary, there is a profound truth, which the instinct of mankind almost unconsciously recognizes. It is true, greatly and deeply true, that the architecture of the North is rude and wild; but it is not true, that, for this reason, we are to condemn it, or despise. Far otherwise: I believe it is in this very character that it deserves our profoundest reverence.

The charts of the world which have been drawn up by modern science have thrown into a narrow space the expression of a vast amount of knowledge, but I have never yet seen any one pictorial enough to enable the spectator to imagine the kind of contrast in physical character which exists between Northern and Southern countries. We know the differences in detail, but we have not that broad glance and grasp which would enable us to feel them in their fulness. We know that gentians grow on the Alps, and olives on the Apennines; but we do not enough conceive for ourselves that variegated mosaic of the world's surface which a bird sees in its migration, that difference between the district of the gentian and of the olive which the stork and the swallow see far off, as they lean upon the sirocco wind. Let us, for a moment, try to raise ourselves even above the level of their flight, and imagine the Mediterranean lying beneath us like an irregular lake, and all its ancient promontories sleeping in the sun: here and there an angry spot of thunder, a grey stain of storm, moving upon the burning field; and here and there a fixed wreath of white volcano smoke, surrounded by its circle of

ashes; but for the most part a great peacefulness of light, Syria and Greece, Italy and Spain, laid like pieces of a golden pavement into the sea-blue, chased, as we stoop nearer to them, with bossy beaten work of mountain chains, and glowing softly with terraced gardens, and flowers heavy with frankincense, mixed among masses of laurel, and orange, and plumy palm, that abate with their grey-green shadows the burning of the marble rocks, and of the ledges of porphyry sloping under lucent sand. Then let us pass farther towards the north, until we see the orient colours change gradually into a vast belt of rainy green, where the pastures of Switzerland, and poplar valleys of France, and dark forests of the Danube and Carpathians stretch from the mouths of the Loire to those of the Volga, seen through clefts in grey swirls of rain-cloud and flaky veils of the mist of the brooks, spreading low along the pasture lands: and then, farther north still, to see the earth heave into mighty masses of leaden rock and heathy moor, bordering with a broad waste of gloomy purple that belt of field and wood, and splintering into irregular and grisly islands amidst the northern seas, beaten by storm, and chilled by ice-drift, and tormented by furious pulses of con-tending tide, until the roots of the last forests fail from among the hill ravines, and the hunger of the north wind bites their peaks into barrenness; and, at last, the wall of ice, durable like iron, sets, deathlike, its white teeth against us out of the polar twilight. And, having once traversed in thought this gradation of the zoned iris of the earth in all its material vastness, let us go down nearer to it, and watch the parallel change in the belt of

animal life; the multitudes of swift and brilliant creatures that glance in the air and sea, or tread the sands of the southern zone; striped zebras and spotted leopards, glistening serpents, and birds arrayed in purple and scarlet. Let us contrast their delicacy and brilliancy of colour, and swiftness of motion, with the frost-cramped strength, and shaggy covering, and dusky plumage of the northern tribes; contrast the Arabian horse with the Shetland, the tiger and leopard with the wolf and bear, the antelope with the elk, the bird of paradise with the osprey; and then, submissively acknowledging the great laws by which the earth and all that it bears are ruled throughout their being, let us not condemn, but rejoice in the expression by man of his own rest in the statutes of the lands that gave him birth. Let us watch him with reverence as he sets side by side the burning gems, and smooths with soft sculpture the jasper pillars, that are to reflect a ceaseless sunshine, and rise into a cloudless sky: but not with less reverence let us stand by him, when, with rough strength and hurried stroke, he smites an uncouth animation out of the rocks which he has torn from among the moss of the moorland, and heaves into the darkened air the pile of iron buttress and rugged wall, instinct with work of an imagination as wild and wayward as the northern sea; creatures of ungainly shape and rigid limb, but full of wolfish life; fierce as the winds that beat, and changeful as the clouds that shade them.

There is, I repeat, no degradation, no reproach in this, but all dignity and honourableness: and we should err grievously in refusing either to recognize as an essential

character of the existing architecture of the North, or to admit as a desirable character in that which it yet may be, this wildness of thought, and roughness of work; this look of mountain brotherhood between the cathedral and the Alp; this magnificence of sturdy power, put forth only the more energetically because the fine finger-touch was chilled away by the frosty wind, and the eye dimmed by the moor-mist, or blinded by the hail; this out-speaking of the strong spirit of men who may not gather redundant fruitage from the earth, nor bask in dreamy benignity of sunshine, but must break the rock for bread, and cleave the forest for fire, and show, even in what they did for their delight, some of the hard habits of the arm and heart that grew on them as they swung the axe or pressed the plough.

If, however, the savageness of Gothic architecture, merely as an expression of its origin among Northern nations, may be considered, in some sort, a noble character, it possesses a higher nobility still, when considered as an index, not of climate, but of religious principle.

In the 13th and 14th paragraphs of Chapter XXI of the first volume of this work, it was noticed that the systems of architectural ornament, properly so called, might be divided into three: – 1. Servile ornament, in which the execution or power of the inferior workman is entirely subjected to the intellect of the higher; – 2. Constitutional ornament, in which the executive inferior power is, to a certain point, emancipated and independent, having a will of its own, yet confessing its inferiority and rendering obedience to higher powers; – and 3. Revolutionary ornament, in which no executive inferiority is admitted

at all. I must here explain the nature of these divisions at somewhat greater length.

Of Servile ornament, the principal schools are the Greek, Ninevite, and Egyptian; but their servility is of different kinds. The Greek master workman was far advanced in knowledge and power above the Assyrian or Egyptian. Neither he nor those for whom he worked could endure the appearance of imperfection in anything; and, therefore, what ornament he appointed to be done by those beneath him was composed of mere geometrical forms, – balls, ridges, and perfectly symmetrical foliage, – which could be executed with absolute precision by line and rule, and were as perfect in their way, when completed, as his own figure sculpture. The Assyrian and Egyptian, on the contrary, less cognisant of accurate form in anything, were content to allow their figure sculpture to be executed by inferior workmen, but lowered the method of its treatment to a standard which every workman could reach, and then trained him by discipline so rigid, that there was no chance of his falling beneath the standard appointed. The Greek gave to the lower workman no subject which he could not perfectly execute. The Assyrian gave him subjects which he could only execute imperfectly, but fixed a legal standard for his imperfection. The workman was, in both systems, a slave.

But in the mediæval, or especially Christian, system of ornament, this slavery is done away with altogether; Christianity having recognized, in small things as well as great, the individual value of every soul. But it not only recognizes its value; it confesses its imperfection, in

only bestowing dignity upon the acknowledgment of unworthiness. That admission of lost power and fallen nature, which the Greek or Ninevite felt to be intensely painful, and, as far as might be, altogether refused, the Christian makes daily and hourly, contemplating the fact of it without fear, as tending, in the end, to God's greater glory. Therefore, to every spirit which Christianity summons to her service, her exhortation is: Do what you can, and confess frankly what you are unable to do; neither let your effort be shortened for fear of failure, nor your confession silenced for fear of shame. And it is, perhaps, the principal admirableness of the Gothic schools of architecture, that they thus receive the results of the labour of inferior minds; and out of fragments full of imperfection, and betraying that imperfection in every touch, indulgently raise up a stately and unaccusable whole.

But the modern English mind has this much in common with that of the Greek, that it intensely desires, in all things, the utmost completion or perfection compatible with their nature. This is a noble character in the abstract, but becomes ignoble when it causes us to forget the relative dignities of that nature itself, and to prefer the perfectness of the lower nature to the imperfection of the higher; not considering that as, judged by such a rule, all the brute animals would be preferable to man, because more perfect in their functions and kind, and yet are always held inferior to him, so also in the works of man, those which are more perfect in their kind are always inferior to those which are, in their nature, liable to more faults and shortcomings. For the finer the nature,

the more flaws it will show through the clearness of it; and it is a law of this universe, that the best things shall be seldomest seen in their best form. The wild grass grows well and strongly, one year with another; but the wheat is, according to the greater nobleness of its nature, liable to the bitterer blight. And therefore, while in all things that we see or do, we are to desire perfection, and strive for it, we are nevertheless not to set the meaner thing, in its narrow accomplishment, above the nobler thing, in its mighty progress; not to esteem smooth minuteness above shattered majesty; not to prefer mean victory to honourable defeat; not to lower the level of our aim, that we may the more surely enjoy the complacency of success. But, above all, in our dealings with the souls of other men, we are to take care how we check, by severe requirement or narrow caution, efforts which might otherwise lead to a noble issue; and, still more, how we withhold our admiration from great excellencies, because they are mingled with rough faults. Now, in the make and nature of every man, however rude or simple, whom we employ in manual labour, there are some powers for better things; some tardy imagination, torpid capacity of emotion, tottering steps of thought, there are, even at the worst; and in most cases it is all our own fault that they *are* tardy or torpid. But they cannot be strengthened, unless we are content to take them in their feebleness, and unless we prize and honour them in their imperfection above the best and most perfect manual skill. And this is what we have to do with all our labourers; to look for the *thoughtful* part of them, and get that out of them, whatever we lose for

it, whatever faults and errors we are obliged to take with it. For the best that is in them cannot manifest itself, but in company with much error. Understand this clearly: You can teach a man to draw a straight line, and to cut one; to strike a curved line, and to carve it; and to copy and carve any number of given lines or forms, with admirable speed and perfect precision; and you find his work perfect of its kind: but if you ask him to think about any of those forms, to consider if he cannot find any better in his own head, he stops; his execution becomes hesitating; he thinks, and ten to one he thinks wrong; ten to one he makes a mistake in the first touch he gives to his work as a thinking being. But you have made a man of him for all that. He was only a machine before, an animated tool.

And observe, you are put to stern choice in this matter. You must either make a tool of the creature, or a man of him. You cannot make both. Men were not intended to work with the accuracy of tools, to be precise and perfect in all their actions. If you will have that precision out of them, and make their fingers measure degrees like cog-wheels, and their arms strike curves like compasses, you must unhumanize them. All the energy of their spirits must be given to make cogs and compasses of themselves. All their attention and strength must go to the accomplishment of the mean act. The eye of the soul must be bent upon the finger-point, and the soul's force must fill all the invisible nerves that guide it, ten hours a day, that it may not err from its steely precision, and so soul and sight be worn away, and the whole human being be lost at last – a heap of sawdust, so far as

its intellectual work in this world is concerned: saved only by its Heart, which cannot go into the form of cogs and compasses, but expands, after the ten hours are over, into fireside humanity. On the other hand, if you will make a man of the working creature, you cannot make a tool. Let him but begin to imagine, to think, to try to do anything worth doing; and the engine-turned precision is lost at once. Out come all his roughness, all his dulness, all his incapability; shame upon shame, failure upon failure, pause after pause: but out comes the whole majesty of him also; and we know the height of it only when we see the clouds settling upon him. And, whether the clouds be bright or dark, there will be transfiguration behind and within them.

And now, reader, look round this English room of yours, about which you have been proud so often, because the work of it was so good and strong, and the ornaments of it so finished. Examine again all those accurate mouldings, and perfect polishings, and unerring adjustments of the seasoned wood and tempered steel. Many a time you have exulted over them, and thought how great England was, because her slightest work was done so thoroughly. Alas! if read rightly, these perfect-nesses are signs of a slavery in our England a thousand times more bitter and more degrading than that of the scourged African, or helot Greek. Men may be beaten, chained, tormented, yoked like cattle, slaughtered like summer flies, and yet remain in one sense, and the best sense, free. But to smother their souls with them, to blight and hew into rotting pollards the suckling branches of their human intelligence, to make the flesh and skin

which, after the worm's work on it, is to see God, into leathern thongs to yoke machinery with, – this is to be slave-masters indeed; and there might be more freedom in England, though her feudal lords' lightest words were worth men's lives, and though the blood of the vexed husbandman dropped in the furrows of her fields, than there is while the animation of her multitudes is sent like fuel to feed the factory smoke, and the strength of them is given daily to be wasted into the fineness of a web, or racked into the exactness of a line.

And, on the other hand, go forth again to gaze upon the old cathedral front, where you have smiled so often at the fantastic ignorance of the old sculptors: examine once more those ugly goblins, and formless monsters, and stern statues, anatomiless and rigid; but do not mock at them, for they are signs of the life and liberty of every workman who struck the stone; a freedom of thought, and rank in scale of being, such as no laws, no charters, no charities can secure; but which it must be the first aim of all Europe at this day to regain for her children.

Let me not be thought to speak wildly or extrava-gantly. It is verily this degradation of the operative into a machine, which, more than any other evil of the times, is leading the mass of the nations everywhere into vain, incoherent, destructive struggling for a freedom of which they cannot explain the nature to themselves. Their universal outcry against wealth, and against nobility, is not forced from them either by the pressure of famine, or the sting of mortified pride. These do much, and have done much in all ages; but the foundations of society

were never yet shaken as they are at this day. It is not that men are ill fed, but that they have no pleasure in the work by which they make their bread, and therefore look to wealth as the only means of pleasure. It is not that men are pained by the scorn of the upper classes, but they cannot endure their own; for they feel that the kind of labour to which they are condemned is verily a degrading one, and makes them less than men. Never had the upper classes so much sympathy with the lower, or charity for them, as they have at this day, and yet never were they so much hated by them: for, of old, the separation between the noble and the poor was merely a wall built by law; now it is a veritable difference in level of standing, a precipice between upper and lower grounds in the field of humanity, and there is pestilential air at the bottom of it. I know not if a day is ever to come when the nature of right freedom will be understood, and when men will see that to obey another man, to labour for him, yield reverence to him or to his place, is not slavery. It is often the best kind of liberty, – liberty from care. The man who says to one, Go, and he goeth, and to another, Come, and he cometh, has, in most cases, more sense of restraint and difficulty than the man who obeys him. The movements of the one are hindered by the burden on his shoulder; of the other by the bridle on his lips: there is no way by which the burden may be lightened; but we need not suffer from the bridle if we do not champ at it. To yield reverence to another, to hold ourselves and our likes at his disposal, is not slavery; often it is the noblest state in which a man can live in this world. There is, indeed, a reverence which is servile,

that is to say, irrational or selfish: but there is also noble reverence, that is to say, reasonable and loving; and a man is never so noble as when he is reverent in this kind; nay, even if the feeling pass the bounds of mere reason, so that it be loving, a man is raised by it. Which had, in reality, most of the serf nature in him, – the Irish peasant who was lying in wait yesterday for his landlord, with his musket muzzle thrust through the ragged hedge; or that old mountain servant, who 200 years ago, at Inverkeithing, gave up his own life and the lives of his seven sons for his chief? – as each fell, calling forth his brother to the death, 'Another for Hector!' And therefore, in all ages and all countries, reverence has been paid and sacrifice made by men to each other, not only without complaint, but rejoicingly; and famine, and peril, and sword, and all evil, and all shame, have been borne willingly in the causes of masters and kings; for all these gifts of the heart ennobled the men who gave, not less than the men who received them, and nature prompted, and God rewarded the sacrifice. But to feel their souls withering within them, unthanked, to find their whole being sunk into an unrecognized abyss, to be counted off into a heap of mechanism numbered with its wheels, and weighed with its hammer strokes – this, nature bade not, – this, God blesses not, – this, humanity for no long time is able to endure.

We have much studied and much perfected, of late, the great civilized invention of the division of labour; only we give it a false name. It is not, truly speaking, the labour that is divided; but the men: – Divided into mere segments of men – broken into small fragments and

crumbs of life; so that all the little piece of intelligence
that is left in a man is not enough to make a pin, or a
nail, but exhausts itself in making the point of a pin or
the head of a nail. Now it is a good and desirable thing,
truly, to make many pins in a day; but if we could only
see with what crystal sand their points were polished, –
sand of human soul, much to be magnified before it can
be discerned for what it is – we should think there might
be some loss in it also. And the great cry that rises from
all our manufacturing cities, louder than their furnace
blast, is all in very deed for this, – that we manufacture
everything there except men; we blanch cotton, and
strengthen steel, and refine sugar, and shape pottery; but
to brighten, to strengthen, to refine, or to form a single
living spirit, never enters into our estimate of advantages.
And all the evil to which that cry is urging our myriads
can be met only in one way: not by teaching nor preach-
ing, for to teach them is but to show them their misery,
and to preach to them, if we do nothing more than
preach, is to mock at it. It can be met only by a right
understanding, on the part of all classes, of what kinds
of labour are good for men, raising them, and making
them happy; by a determined sacrifice of such con-
venience, or beauty, or cheapness as is to be got only
by the degradation of the workman; and by equally
determined demand for the products and results of
healthy and ennobling labour.

And how, it will be asked, are these products to be
recognized, and this demand to be regulated? Easily: by
the observance of three broad and simple rules:

1. Never encourage the manufacture of any article

not absolutely necessary, in the production of which *Invention* has no share.

2. Never demand an exact finish for its own sake, but only for some practical or noble end.

3. Never encourage imitation or copying of any kind, except for the sake of preserving records of great works.

The second of these principles is the only one which directly rises out of the consideration of our immediate subject; but I shall briefly explain the meaning and extent of the first also, reserving the enforcement of the third for another place.

1. Never encourage the manufacture of anything not necessary, in the production of which invention has no share.

For instance. Glass beads are utterly unnecessary, and there is no design or thought employed in their manufacture. They are formed by first drawing out the glass into rods; these rods are chopped up into fragments of the size of beads by the human hand, and the fragments are then rounded in the furnace. The men who chop up the rods sit at their work all day, their hands vibrating with a perpetual and exquisitely timed palsy, and the beads dropping beneath their vibration like hail. Neither they, nor the men who draw out the rods or fuse the fragments, have the smallest occasion for the use of any single human faculty; and every young lady, therefore, who buys glass beads is engaged in the slave-trade, and in a much more cruel one than that which we have so long been endeavouring to put down.

But glass cups and vessels may become the subjects of exquisite invention; and if in buying these we pay

for the invention, that is to say, for the beautiful form, or colour, or engraving, and not for mere finish of execution, we are doing good to humanity.

So, again, the cutting of precious stones, in all ordinary cases, requires little exertion of any mental faculty; some tact and judgment in avoiding flaws, and so on, but nothing to bring out the whole mind. Every person who wears cut jewels merely for the sake of their value is, therefore, a slave-driver.

But the working of the goldsmith, and the various designing of grouped jewellery and enamel-work, may become the subject of the most noble human intelligence. Therefore, money spent in the purchase of well-designed plate, of precious engraved vases, cameos, or enamels, does good to humanity; and, in work of this kind, jewels may be employed to heighten its splendour; and their cutting is then a price paid for the attainment of a noble end, and thus perfectly allowable.

I shall perhaps press this law farther elsewhere, but our immediate concern is chiefly with the second, namely, never to demand an exact finish, when it does not lead to a noble end. For observe, I have only dwelt upon the rudeness of Gothic, or any other kind of imperfectness, as admirable, where it was impossible to get design or thought without it. If you are to have the thought of a rough and untaught man, you must have it in a rough and untaught way; but from an educated man, who can without effort express his thoughts in an educated way, take the graceful expression, and be thankful. Only *get* the thought, and do not silence the peasant because he cannot speak good grammar, or

until you have taught him his grammar. Grammar and refinement are good things, both, only be sure of the better thing first. And thus in art, delicate finish is desirable from the greatest masters, and is always given by them. In some places Michael Angelo, Leonardo, Phidias, Perugino, Turner, all finished with the most exquisite care; and the finish they give always leads to the fuller accomplishment of their noble purposes. But lower men than these cannot finish, for it requires consummate knowledge to finish consummately, and then we must take their thoughts as they are able to give them. So the rule is simple: Always look for invention first, and after that, for such execution as will help the invention, and as the inventor is capable of without painful effort, and *no more*. Above all, demand no refinement of execution where there is no thought, for that is slaves' work, unredeemed. Rather choose rough work than smooth work, so only that the practical purpose be answered, and never imagine there is reason to be proud of anything that may be accomplished by patience and sand-paper.

I shall only give one example, which however will show the reader what I mean, from the manufacture already alluded to, that of glass. Our modern glass is exquisitely clear in its substance, true in its form, accurate in its cutting. We are proud of this. We ought to be ashamed of it. The old Venice glass was muddy, inaccurate in all its forms, and clumsily cut, if at all. And the old Venetian was justly proud of it. For there is this difference between the English and Venetian workman, that the former thinks only of accurately matching his patterns, and getting his curves perfectly true and his edges per-

fectly sharp, and becomes a mere machine for rounding curves and sharpening edges; while the old Venetian cared not a whit whether his edges were sharp or not, but he invented a new design for every glass that he made, and never moulded a handle or a lip without a new fancy in it. And therefore, though some Venetian glass is ugly and clumsy enough when made by clumsy and uninventive workmen, other Venetian glass is so lovely in its forms that no price is too great for it; and we never see the same form in it twice. Now you cannot have the finish and the varied form too. If the workman is thinking about his edges, he cannot be thinking of his design; if of his design, he cannot think of his edges. Choose whether you will pay for the lovely form or the perfect finish, and choose at the same moment whether you will make the worker a man or a grindstone.

Nay, but the reader interrupts me, – 'If the workman can design beautifully, I would not have him kept at the furnace. Let him be taken away and made a gentleman, and have a studio, and design his glass there, and I will have it blown and cut for him by common workmen, and so I will have my design and my finish too.'

All ideas of this kind are founded upon two mistaken suppositions: the first, that one man's thoughts can be, or ought to be, executed by another man's hands; the second, that manual labour is a degradation, when it is governed by intellect.

On a large scale, and in work determinable by line and rule, it is indeed both possible and necessary that the thoughts of one man should be carried out by the labour of others; in this sense I have already defined the

best architecture to be the expression of the mind of manhood by the hands of childhood. But on a smaller scale, and in a design which cannot be mathematically defined, one man's thoughts can never be expressed by another: and the difference between the spirit of touch of the man who is inventing, and of the man who is obeying directions, is often all the difference between a great and a common work of art. How wide the separation is between original and second-hand execution, I shall endeavour to show elsewhere; it is not so much to our purpose here as to mark the other and more fatal error of despising manual labour when governed by intellect; for it is no less fatal an error to despise it when thus regulated by intellect, than to value it for its own sake. We are always in these days endeavouring to separate the two; we want one man to be always thinking, and another to be always working, and we call one a gentleman, and the other an operative; whereas the workman ought often to be thinking, and the thinker often to be working, and both should be gentlemen, in the best sense. As it is, we make both ungentle, the one envying, the other despising, his brother; and the mass of society is made up of morbid thinkers, and miserable workers. Now it is only by labour that thought can be made healthy, and only by thought that labour can be made happy, and the two cannot be separated with impunity. It would be well if all of us were good handicraftsmen in some kind, and the dishonour of manual labour done away with altogether; so that though there should still be a trenchant distinction of race between nobles and commoners, there should not, among the

latter, be a trenchant distinction of employment, as between idle and working men, or between men of liberal and illiberal professions. All professions should be liberal, and there should be less pride felt in peculiarity of employment, and more in excellence of achievement. And yet more, in each several profession, no master should be too proud to do its hardest work. The painter should grind his own colours; the architect work in the mason's yard with his men; the master-manufacturer be himself a more skilful operative than any man in his mills; and the distinction between one man and another be only in experience and skill, and the authority and wealth which these must naturally and justly obtain.

I should be led far from the matter in hand, if I were to pursue this interesting subject. Enough, I trust, has been said to show the reader that the rudeness or imperfection which at first rendered the term 'Gothic' one of reproach is indeed, when rightly understood, one of the most noble characters of Christian architecture, and not only a noble but an *essential* one. It seems a fantastic paradox, but it is nevertheless a most important truth, that no architecture can be truly noble which is *not* imperfect. And this is easily demonstrable. For since the architect, whom we will suppose capable of doing all in perfection, cannot execute the whole with his own hands, he must either make slaves of his workmen in the old Greek, and present English fashion, and level his work to a slave's capacities, which is to degrade it; or else he must take his workmen as he finds them, and let them show their weaknesses together with their strength, which will involve the Gothic imperfection,

but render the whole work as noble as the intellect of the age can make it.

But the principle may be stated more broadly still. I have confined the illustration of it to architecture, but I must not leave it as if true of architecture only. Hitherto I have used the words imperfect and perfect merely to distinguish between work grossly unskilful, and work executed with average precision and science; and I have been pleading that any degree of unskilfulness should be admitted, so only that the labourer's mind had room for expression. But, accurately speaking, no good work whatever can be perfect, and *the demand for perfection is always a sign of a misunderstanding of the ends of art.*

This is for two reasons, both based on everlasting laws. The first, that no great man ever stops working till he has reached his point of failure: that is to say, his mind is always far in advance of his powers of execution, and the latter will now and then give way in trying to follow it; besides that he will always give to the inferior portions of his work only such inferior attention as they require; and according to his greatness he becomes so accustomed to the feeling of dissatisfaction with the best he can do, that in moments of lassitude or anger with himself he will not care though the beholder be dissatisfied also. I believe there has only been one man who would not acknowledge this necessity, and strove always to reach perfection, Leonardo; the end of his vain effort being merely that he would take ten years to a picture and leave it unfinished. And therefore, if we are to have great men working at all, or less men doing their best, the work will be imperfect, however beautiful. Of human

work none but what is bad can be perfect, in its own bad way.*

The second reason is, that imperfection is in some sort essential to all that we know of life. It is the sign of life in a mortal body, that is to say, of a state of progress and change. Nothing that lives is, or can be, rigidly perfect; part of it is decaying, part nascent. The foxglove blossom, – a third part bud, a third part past, a third part in full bloom, – is a type of the life of this world. And in all things that live there are certain irregularities and deficiencies which are not only signs of life, but sources of beauty. No human face is exactly the same in its lines on each side, no leaf perfect in its lobes, no branch in its symmetry. All admit irregularity as they imply change; and to banish imperfection is to destroy expression, to check exertion, to paralyze vitality. All things are literally better, lovelier, and more beloved for the imperfections which have been divinely appointed, that the law of human life may be Effort, and the law of human judgment, Mercy.

Accept this then for a universal law, that neither architecture nor any other noble work of man can be good unless it be imperfect; and let us be prepared for the otherwise strange fact, which we shall discern clearly as we approach the period of the Renaissance, that the first cause of the fall of the arts of Europe was a relentless

* The Elgin marbles are supposed by many persons to be 'perfect'. In the most important portions they indeed approach perfection, but only there. The draperies are unfinished, the hair and wool of the animals are unfinished, and the entire bas-reliefs of the frieze are roughly cut.

requirement of perfection, incapable alike either of being silenced by veneration for greatness, or softened into forgiveness of simplicity.

Thus far then of the Rudeness or Savageness, which is the first mental element of Gothic architecture. It is an element in many other healthy architectures also, as the Byzantine and Romanesque; but true Gothic cannot exist without it.

The second mental element above named was CHANGEFULNESS, or Variety.

I have already enforced the allowing independent operation to the inferior workman, simply as a duty *to him*, and as ennobling the architecture by rendering it more Christian. We have now to consider what reward we obtain for the performance of this duty, namely, the perpetual variety of every feature of the building.

Wherever the workman is utterly enslaved, the parts of the building must of course be absolutely like each other; for the perfection of his execution can only be reached by exercising him in doing one thing, and giving him nothing else to do. The degree in which the workman is degraded may be thus known at a glance, by observing whether the several parts of the building are similar or not; and if, as in Greek work, all the capitals are alike, and all the mouldings unvaried, then the degradation is complete; if, as in Egyptian or Ninevite work, though the manner of executing certain figures is always the same, the order of design is perpetually varied, the degradation is less total; if, as in Gothic work, there is perpetual change both in design and execution, the workman must have been altogether set free.

How much the beholder gains from the liberty of the labourer may perhaps be questioned in England, where one of the strongest instincts in nearly every mind is that Love of Order which makes us desire that our house windows should pair like our carriage horses, and allows us to yield our faith unhesitatingly to architectural theories which fix a form for everything, and forbid variation from it. I would not impeach love of order: it is one of the most useful elements of the English mind; it helps us in our commerce and in all purely practical matters; and it is in many cases one of the foundation stones of morality. Only do not let us suppose that love of order is love of art. It is true that order, in its highest sense, is one of the necessities of art, just as time is a necessity of music; but love of order has no more to do with our right enjoyment of architecture or painting, than love of punctuality with the appreciation of an opera. Experience, I fear, teaches us that accurate and methodical habits in daily life are seldom characteristic of those who either quickly perceive, or richly possess, the creative powers of art; there is, however, nothing inconsistent between the two instincts, and nothing to hinder us from retaining our business habits, and yet fully allowing and enjoying the noblest gifts of Invention. We already do so, in every other branch of art except architecture, and we only do *not* so there because we have been taught that it would be wrong. Our architects gravely inform us that, as there are four rules of arithmetic, there are five orders of architecture; we, in our simplicity, think that this sounds consistent, and believe them. They inform us also that there is one proper form

for Corinthian capitals, another for Doric, and another for Ionic. We, considering that there is also a proper form for the letters A, B, and C, think that this also sounds consistent, and accept the proposition. Understanding, therefore, that one form of the said capitals is proper, and no other, and having a conscientious horror of all impropriety, we allow the architect to provide us with the said capitals, of the proper form, in such and such a quantity, and in all other points to take care that the legal forms are observed; which having done, we rest in forced confidence that we are well housed.

But our higher instincts are not deceived. We take no pleasure in the building provided for us, resembling that which we take in a new book or a new picture. We may be proud of its size, complacent in its correctness, and happy in its convenience. We may take the same pleasure in its symmetry and workmanship as in a well-ordered room, or a skilful piece of manufacture. And this we suppose to be all the pleasure that architecture was ever intended to give us. The idea of reading a building as we would read Milton or Dante, and getting the same kind of delight out of the stones as out of the stanzas, never enters our mind for a moment. And for good reason; – There is indeed rhythm in the verses, quite as strict as the symmetries or rhythm of the architecture, and a thousand times more beautiful, but there is something else than rhythm. The verses were neither made to order, nor to match, as the capitals were; and we have therefore a kind of pleasure in them other than a sense of propriety. But it requires a strong effort of common sense to shake ourselves quit of all that we have been

taught for the last two centuries, and wake to the perception of a truth just as simple and certain as it is new: that great art, whether expressing itself in words, colours, or stones, does *not* say the same thing over and over again; that the merit of architectural, as of every other art, consists in its saying new and different things; that to repeat itself is no more a characteristic of genius in marble than it is of genius in print; and that we may, without offending any laws of good taste, require of an architect, as we do of a novelist, that he should be not only correct, but entertaining.

Yet all this is true, and self-evident; only hidden from us, as many other self-evident things are, by false teaching. Nothing is a great work of art, for the production of which either rules or models can be given. Exactly so far as architecture works on known rules, and from given models, it is not an art, but a manufacture; and it is, of the two procedures, rather less rational (because more easy) to copy capitals or mouldings from Phidias, and call ourselves architects, than to copy heads and hands from Titian, and call ourselves painters.

Let us then understand at once that change or variety is as much a necessity to the human heart and brain in buildings as in books; that there is no merit, though there is some occasional use, in monotony; and that we must no more expect to derive either pleasure or profit from an architecture whose ornaments are of one pattern, and whose pillars are of one proportion, than we should out of a universe in which the clouds were all of one shape, and the trees all of one size.

And this we confess in deeds, though not in words.

All the pleasure which the people of the nineteenth century take in art, is in pictures, sculpture, minor objects of virtù, or mediæval architecture, which we enjoy under the term picturesque: no pleasure is taken anywhere in modern buildings, and we find all men of true feeling delighting to escape out of modern cities into natural scenery: hence, as I shall hereafter show, that peculiar love of landscape, which is characteristic of the age. It would be well, if in all other matters, we were as ready to put up with what we dislike, for the sake of compliance with established law, as we are in architecture.

How so debased a law ever came to be established, we shall see when we come to describe the Renaissance schools; here we have only to note, as a second most essential element of the Gothic spirit, that it broke through that law wherever it found it in existence; it not only dared, but delighted in, the infringement of every servile principle; and invented a series of forms of which the merit was, not merely that they were new, but that they were *capable of perpetual novelty*. The pointed arch was not merely a bold variation from the round, but it admitted of millions of variations in itself; for the proportions of a pointed arch are changeable to infinity, while a circular arch is always the same. The grouped shaft was not merely a bold variation from the single one, but it admitted of millions of variations in its grouping, and in the proportions resultant from its grouping. The introduction of tracery was not only a startling change in the treatment of window lights, but admitted endless changes in the interlacement of the tracery bars themselves. So that, while in all living Christian

architecture the love of variety exists, the Gothic schools exhibited that love in culminating energy; and their influence, wherever it extended itself, may be sooner and farther traced by this character than by any other; the tendency to the adoption of Gothic types being always first shown by greater irregularity, and richer variation in the forms of architecture it is about to supersede, long before the appearance of the pointed arch or of any other recognizable *outward* sign of the Gothic mind.

We must, however, herein note carefully what distinction there is between a healthy and a diseased love of change; for as it was in healthy love of change that the Gothic architecture rose, it was partly in consequence of diseased love of change that it was destroyed. In order to understand this clearly, it will be necessary to consider the different ways in which change and monotony are presented to us in nature; both having their use, like darkness and light, and the one incapable of being enjoyed without the other: change being most delightful after some prolongation of monotony, as light appears most brilliant after the eyes have been for some time closed.

I believe that the true relations of monotony and change may be most simply understood by observing them in music. We may therein notice first, that there is a sublimity and majesty in monotony, which there is not in rapid or frequent variation. This is true throughout all nature. The greater part of the sublimity of the sea depends on its monotony; so also that of desolate moor and mountain scenery; and especially the sublimity of

motion, as in the quiet, unchanged fall and rise of an engine beam. So also there is sublimity in darkness which there is not in light.

Again, monotony after a certain time, or beyond a certain degree, becomes either uninteresting or intolerable, and the musician is obliged to break it in one of two ways: either while the air or passage is perpetually repeated, its notes are variously enriched and harmonized; or else, after a certain number of repeated passages, an entirely new passage is introduced, which is more or less delightful according to the length of the previous monotony. Nature, of course, uses both these kinds of variation perpetually. The sea-waves, resembling each other in general mass, but none like its brother in minor divisions and curves, are a monotony of the first kind; the great plain, broken by an emergent rock or clump of trees, is a monotony of the second.

Farther: in order to the enjoyment of the change in either case, a certain degree of patience is required from the hearer or observer. In the first case, he must be satisfied to endure with patience the recurrence of the great masses of sound or form, and to seek for entertainment in a careful watchfulness of the minor details. In the second case, he must bear patiently the infliction of the monotony for some moments, in order to feel the full refreshment of the change. This is true even of the shortest musical passage in which the element of monotony is employed. In cases of more majestic monotony, the patience required is so considerable that it becomes a kind of pain, – a price paid for the future pleasure.

Again: the talent of the composer is not in the monotony, but in the changes: he may show feeling and taste by his use of monotony in certain places or degrees; that is to say, by his *various* employment of it; but it is always in the new arrangement or invention that his intellect is shown, and not in the monotony which relieves it.

Lastly: if the pleasure of change be too often repeated, it ceases to be delightful, for then change itself becomes monotonous, and we are driven to seek delight in extreme and fantastic degrees of it. This is the diseased love of change of which we have above spoken.

From these facts we may gather generally that monotony is, and ought to be, in itself painful to us, just as darkness is; that an architecture which is altogether monotonous is a dark or dead architecture; and of those who love it, it may be truly said, 'they love darkness rather than light.' But monotony in certain measure, used in order to give value to change, and above all, that *transparent* monotony, which, like the shadows of a great painter, suffers all manner of dimly suggested form to be seen through the body of it, is an essential in architectural as in all other composition; and the endurance of monotony has about the same place in a healthy mind that the endurance of darkness has: that is to say, as a strong intellect will have pleasure in the solemnities of storm and twilight, and in the broken and mysterious lights that gleam among them, rather than in mere brilliancy and glare, while a frivolous mind will dread the shadow and the storm; and as a great man will be ready to endure much darkness of fortune in order to reach greater eminence of power or felicity, while an

inferior man will not pay the price; exactly in like manner a great mind will accept, or even delight in, monotony which would be wearisome to an inferior intellect, because it has more patience and power of expectation, and is ready to pay the full price for the great future pleasure of change. But in all cases it is not that the noble nature loves monotony, any more than it loves darkness or pain. But it can bear with it, and receive a high pleasure in the endurance or patience, a pleasure necessary to the well-being of this world; while those who will not submit to the temporary sameness, but rush from one change to another, gradually dull the edge of change itself, and bring a shadow and weariness over the whole world from which there is no more escape.

From these general uses of variety in the economy of the world, we may at once understand its use and abuse in architecture. The variety of the Gothic schools is the more healthy and beautiful, because in many cases it is entirely unstudied, and results, not from mere love of change, but from practical necessities. For in one point of view Gothic is not only the best, but the *only rational* architecture, as being that which can fit itself most easily to all services, vulgar or noble. Undefined in its slope of roof, height of shaft, breadth of arch, or disposition of ground plan, it can shrink into a turret, expand into a hall, coil into a staircase, or spring into a spire, with undegraded grace and unexhausted energy; and when-ever it finds occasion for change in its form or purpose, it submits to it without the slightest sense of loss either to its unity or majesty, – subtle and flexible like a fiery serpent, but ever attentive to the voice of the charmer.

And it is one of the chief virtues of the Gothic builders, that they never suffered ideas of outside symmetries and consistencies to interfere with the real use and value of what they did. If they wanted a window, they opened one; a room, they added one; a buttress, they built one; utterly regardless of any established conventionalities of external appearance, knowing (as indeed it always happened) that such daring interruptions of the formal plan would rather give additional interest to its symmetry than injure it. So that, in the best times of Gothic, a useless window would rather have been opened in an unexpected place for the sake of the surprise, than a useful one forbidden for the sake of symmetry. Every successive architect, employed upon a great work, built the pieces he added in his own way, utterly regardless of the style adopted by his predecessors; and if two towers were raised in nominal correspondence at the sides of a cathedral front, one was nearly sure to be different from the other, and in each the style at the top to be different from the style at the bottom.

These marked variations were, however, only permitted as part of the great system of perpetual change which ran through every member of Gothic design, and rendered it as endless a field for the beholder's inquiry as for the builder's imagination: change, which in the best schools is subtle and delicate, and rendered more delightful by intermingling of a noble monotony; in the more barbaric schools is somewhat fantastic and redundant; but, in all, a necessary and constant condition of the life of the school. Sometimes the variety is in one feature, sometimes in another; it may be in the capitals

or crockets, in the niches or the traceries, or in all together, but in some one or other of the features it will be found always. If the mouldings are constant, the surface sculpture will change; if the capitals are of a fixed design, the traceries will change; if the traceries are monotonous, the capitals will change; and if even, as in some fine schools, the early English for example, there is the slightest approximation to an unvarying type of mouldings, capitals, and floral decoration, the variety is found in the disposition of the masses, and in the figure sculpture.

I must now refer for a moment, before we quit the consideration of this, the second mental element of Gothic, to the opening of the third chapter of the *Seven Lamps of Architecture*, in which the distinction was drawn between man gathering and man governing; between his acceptance of the sources of delight from nature, and his development of authoritative or imaginative power in their arrangement: for the two mental elements, not only of Gothic, but of all good architecture, which we have just been examining, belong to it, and are admirable in it, chiefly as it is, more than any other subject of art, the work of man, and the expression of the average power of man. A picture or poem is often little more than a feeble utterance of man's admiration of something out of himself; but architecture approaches more to a creation of his own, born of his necessities, and express-ive of his nature. It is also, in some sort, the work of the whole race, while the picture or statue is the work of one only, in most cases more highly gifted than his fellows. And therefore we may expect that the first two

elements of good architecture should be expressive of some great truths commonly belonging to the whole race, and necessary to be understood or felt by them in all their work that they do under the sun. And observe what they are: the confession of Imperfection, and the confession of Desire of Change. The building of the bird and the bee needs not express anything like this. It is perfect and unchanging. But just because we are something better than birds or bees, our building must confess that we have not reached the perfection we can imagine, and cannot rest in the condition we have attained. If we pretend to have reached either perfection or satisfaction, we have degraded ourselves and our work. God's work only may express that; but ours may never have that sentence written upon it, – 'And behold, it was very good.' And, observe again, it is not merely as it renders the edifice a book of various knowledge, or a mine of precious thought, that variety is essential to its nobleness. The vital principle is not the love of *Knowledge*, but the love of *Change*. It is that strange *disquietude* of the Gothic spirit that is its greatness; that restlessness of the dreaming mind, that wanders hither and thither among the niches, and flickers feverishly around the pinnacles, and frets and fades in labyrinthine knots and shadows along wall and roof, and yet is not satisfied, nor shall be satisfied. The Greek could stay in his triglyph furrow, and be at peace; but the work of the Gothic heart is fretwork still, and it can neither rest in, nor from, its labour, but must pass on, sleeplessly, until its love of change shall be pacified for ever in the change that must come alike on them that wake and them that sleep.

The third constituent element of the Gothic mind was stated to be NATURALISM; that is to say, the love of natural objects for their own sake, and the effort to represent them frankly, unconstrained by artistical laws.

This characteristic of the style partly follows in necessary connection with those named above. For, so soon as the workman is left free to represent what subjects he chooses, he must look to the nature that is round him for material, and will endeavour to represent it as he sees it, with more or less accuracy according to the skill he possesses, and with much play of fancy, but with small respect for law. There is, however, a marked distinction between the imaginations of the Western and Eastern races, even when both are left free; the Western, or Gothic, delighting most in the representation of facts, and the Eastern (Arabian, Persian, and Chinese) in the harmony of colours and forms. Each of these intellectual dispositions has its particular forms of error and abuse [. . .]

Of the various forms of resultant mischief it is not here the place to speak; the reader may already be somewhat wearied with a statement which has led us apparently so far from our immediate subject. But the digression was necessary, in order that I might clearly define the sense in which I use the word Naturalism when I state it to be the third most essential characteristic of Gothic architecture. I mean that the Gothic builders belong to the central or greatest rank in *both* the classifications of artists which we have just made; that considering all artists as either men of design, men of facts, or men of both, the Gothic builders were men of both;

and that again, considering all artists as either Purists, Naturalists, or Sensualists, the Gothic builders were Naturalists.

I say first, that the Gothic builders were of that central class which unites fact with design; but that the part of the work which was more especially their own was the truthfulness. Their power of artistical invention or arrangement was not greater than that of Romanesque and Byzantine workmen: by those workmen they were taught the principles, and from them received their models, of design; but to the ornamental feeling and rich fancy of the Byzantine the Gothic builder added a love of *fact* which is never found in the South. Both Greek and Roman used conventional foliage in their orna-ment, passing into something that was not foliage at all, knotting itself into strange cup-like buds or clusters, and growing out of lifeless rods instead of stems; the Gothic sculptor received these types, at first, as things that ought to be, just as we have a second time received them; but he could not rest in them. He saw there was no veracity in them, no knowledge, no vitality. Do what he would, he could not help liking the true leaves better; and cautiously, a little at a time, he put more of nature into his work, until at last it was all true, retaining, nevertheless, every valuable character of the original well-disciplined and designed arrangement.

Nor is it only in external and visible subject that the Gothic workman wrought for truth: he is as firm in his rendering of imaginative as of actual truth; that is to say, when an idea would have been by a Roman, or Byzantine, symbolically represented, the Gothic mind

realizes it to the utmost. For instance, the purgatorial fire is represented in the mosaic of Torcello (Romanesque) as a red stream, longitudinally striped like a riband, descending out of the throne of Christ, and gradually extending itself to envelop the wicked. When we are once informed what this means, it is enough for its purpose; but the Gothic inventor does not leave the sign in need of interpretation. He makes the fire as like real fire as he can; and in the porch of St Maclou at Rouen the sculptured flames burst out of the Hades gate, and flicker up, in writhing tongues of stone, through the interstices of the niches, as if the church itself were on fire. This is an extreme instance, but it is all the more illustrative of the entire difference in temper and thought between the two schools of art, and of the intense love of veracity which influenced the Gothic design.

I do not say that this love of veracity is always healthy in its operation. I have above noticed the errors into which it falls from despising design; and there is another kind of error noticeable in the instance just given, in which the love of truth is too hasty, and seizes on a surface truth instead of an inner one. For in representing the Hades fire, it is not the mere *form* of the flame which needs most to be told, but its unquenchableness, its Divine ordainment and limitation, and its inner fierceness, not physical and material, but in being the expression of the wrath of God. And these things are not to be told by imitating the fire that flashes out of a bundle of sticks. If we think over his symbol a little, we shall perhaps find that the Romanesque builder told more truth in that likeness of a blood-red stream, flowing

between definite shores, and out of God's throne, and expanding, as if fed by a perpetual current, into the lake wherein the wicked are cast, than the Gothic builder in those torch-flickerings about his niches. But this is not to our immediate purpose; I am not at present to insist upon the faults into which the love of truth was led in the later Gothic times, but on the feeling itself, as a glorious and peculiar characteristic of the Northern builders. For, observe, it is not, even in the above instance, love of truth, but want of thought, which *causes* the fault. The love of truth, as such, is good, but when it is misdirected by thoughtlessness or over-excited by vanity, and either seizes on facts of small value, or gathers them chiefly that it may boast of its grasp and apprehension, its work may well become dull or offensive. Yet let us not, therefore, blame the inherent love of facts, but the incautiousness of their selection, and impertinence of their statement.

I said, in the second place, that Gothic work, when referred to the arrangement of all art, as purist, naturalist, or sensualist, was naturalist. This character follows necessarily on its extreme love of truth, prevailing over the sense of beauty, and causing it to take delight in portraiture of every kind, and to express the various characters of the human countenance and form, as it did the varieties of leaves and the ruggedness of branches. And this tendency is both increased and ennobled by the same Christian humility which we saw expressed in the first character of Gothic work, its rudeness. For as that resulted from a humility which confessed the imperfection of the *workman*, so this naturalist portraiture is

rendered more faithful by the humility which confesses the imperfection of the *subject*. The Greek sculptor could neither bear to confess his own feebleness, nor to tell the faults of the forms that he portrayed. But the Christian workman, believing that all is finally to work together for good, freely confesses both, and neither seeks to disguise his own roughness of work, nor his subject's roughness of make. Yet this frankness being joined, for the most part, with depth of religious feeling in other directions, and especially with charity, there is some-times a tendency to Purism in the best Gothic sculpture; so that it frequently reaches great dignity of form and tenderness of expression, yet never so as to lose the veracity of portraiture wherever portraiture is possible: not exalting its kings into demi-gods, nor its saints into archangels, but giving what kingliness and sanctity was in them, to the full, mixed with due record of their faults; and this in the most part with a great indifference like that of Scripture history, which sets down, with unmoved and unexcusing resoluteness, the virtues and errors of all men of whom it speaks, often leaving the reader to form his own estimate of them, without an indication of the judgment of the historian. And this veracity is carried out by the Gothic sculptors in the minuteness and gener-ality, as well as the equity, of their delineation: for they do not limit their art to the portraiture of saints and kings, but introduce the most familiar scenes and most simple subjects: filling up the backgrounds of Scripture histories with vivid and curious representations of the commonest incidents of daily life, and availing them-selves of every occasion in which, either as a symbol, or

an explanation of a scene or time, the things familiar to the eye of the workman could be introduced and made of account. Hence Gothic sculpture and painting are not only full of valuable portraiture of the greatest men, but copious records of all the domestic customs and inferior arts of the ages in which it flourished.*

There is, however, one direction in which the Naturalism of the Gothic workmen is peculiarly manifested; and this direction is even more characteristic of the school than the Naturalism itself; I mean their peculiar fondness for the forms of Vegetation. In rendering the various circumstances of daily life, Egyptian and Ninevite sculpture is as frank and as diffuse as the Gothic. From the highest pomps of state or triumphs of battle, to the most trivial domestic arts and amusements, all is taken advantage of to fill the field of granite with the perpetual interest of a crowded drama; and the early Lombardic and Romanesque sculpture is equally copious in its description of the familiar circumstances of war and the chase. But in all the scenes portrayed by the workmen of these nations, vegetation occurs only as an explanatory accessary; the reed is introduced to mark the course of the river, or the tree to mark the covert of the wild beast, or the ambush of the enemy, but there is no especial

* The best art either represents the facts of its own day, or, if facts of the past, expresses them with accessaries of the time in which the work was done. All good art, representing past events, is therefore full of the most frank anachronism, and always *ought* to be. No painter has any business to be an antiquarian. We do not want his impressions or suppositions respecting things that are past. We want his clear assertions respecting things present.

interest in the forms of the vegetation strong enough to induce them to make it a subject of separate and accurate study. Again, among the nations who followed the arts of design exclusively, the forms of foliage introduced were meagre and general, and their real intricacy and life were neither admired nor expressed. But to the Gothic workman the living foliage became a subject of intense affection, and he struggled to render all its characters with as much accuracy as was compatible with the laws of his design and the nature of his material, not unfrequently tempted in his enthusiasm to transgress the one and disguise the other.

There is a peculiar significance in this, indicative both of higher civilization and gentler temperament, than had before been manifested in architecture. Rudeness, and the love of change, which we have insisted upon as the first elements of Gothic, are also elements common to all healthy schools. But here is a softer element mingled with them, peculiar to the Gothic itself. The rudeness or ignorance which would have been painfully exposed in the treatment of the human form, are still not so great as to prevent the successful rendering of the wayside herbage; and the love of change, which becomes morbid and feverish in following the haste of the hunter and the rage of the combatant, is at once soothed and satisfied as it watches the wandering of the tendril, and the budding of the flower. Nor is this all: the new direction of mental interest marks an infinite change in the means and the habits of life. The nations whose chief support was in the chase, whose chief interest was in the battle, whose chief pleasure was in the banquet, would take

small care respecting the shapes of leaves and flowers; and notice little in the forms of the forest trees which sheltered them, except the signs indicative of the wood which would make the toughest lance, the closest roof, or the clearest fire. The affectionate observation of the grace and outward character of vegetation is the sure sign of a more tranquil and gentle existence, sustained by the gifts, and gladdened by the splendour, of the earth. In that careful distinction of species, and richness of delicate and undisturbed organization, which characterize the Gothic design, there is the history of rural and thoughtful life, influenced by habitual tenderness, and devoted to subtle inquiry; and every discriminating and delicate touch of the chisel, as it rounds the petal or guides the branch, is a prophecy of the development of the entire body of the natural sciences, beginning with that of medicine, of the recovery of literature, and the establishment of the most necessary principles of domestic wisdom and national peace.

I have before alluded to the strange and vain supposition, that the original conception of Gothic architecture had been derived from vegetation, – from the symmetry of avenues, and the interlacing of branches. It is a supposition which never could have existed for a moment in the mind of any person acquainted with early Gothic; but, however idle as a theory, it is most valuable as a testimony to the character of the perfected style. It is precisely because the reverse of this theory is the fact, because the Gothic did not arise out of, but developed itself into a resemblance to vegetation, that this resemblance is so instructive as an indication of the temper of

the builders. It was no chance suggestion of the form of an arch from the bending of a bough, but a gradual and continual discovery of a beauty in natural forms which could be more and more perfectly transferred into those of stone, that influenced at once the heart of the people, and the form of the edifice. The Gothic architecture arose in massy and mountainous strength, axe-hewn, and iron-bound, block heaved upon block by the monk's enthusiasm and the soldier's force; and cramped and stanchioned into such weight of grisly wall, as might bury the anchoret in darkness, and beat back the utmost storm of battle, suffering but by the same narrow crosslet the passing of the sunbeam, or of the arrow. Gradually, as that monkish enthusiasm became more thoughtful, and as the sound of war became more and more intermittent beyond the gates of the convent or the keep, the stony pillar grew slender and the vaulted roof grew light, till they had wreathed themselves into the semblance of the summer woods at their fairest, and of the dead field-flowers, long trodden down in blood, sweet monumental statues were set to bloom for ever, beneath the porch of the temple, or the canopy of the tomb.

Nor is it only as a sign of greater gentleness or refinement of mind, but as a proof of the best possible direction of this refinement, that the tendency of the Gothic to the expression of vegetative life is to be admired. That sentence of Genesis, 'I have given thee every green herb for meat,' like all the rest of the book, has a profound symbolical as well as a literal meaning. It is not merely the nourishment of the body, but the food of the soul, that is intended. The green herb is, of all nature, that

which is most essential to the healthy spiritual life of man. Most of us do not need fine scenery; the precipice and the mountain peak are not intended to be seen by all men, – perhaps their power is greatest over those who are unaccustomed to them. But trees and fields and flowers were made for all, and are necessary for all. God has connected the labour which is essential to the bodily sustenance with the pleasures which are healthiest for the heart; and while He made the ground stubborn, He made its herbage fragrant, and its blossoms fair. The proudest architecture that man can build has no higher honour than to bear the image and recall the memory of that grass of the field which is, at once, the type and the support of his existence; the goodly building is then most glorious when it is sculptured into the likeness of the leaves of Paradise; and the great Gothic spirit, as we showed it to be noble in its disquietude, is also noble in its hold of nature; it is, indeed, like the dove of Noah, in that she found no rest upon the face of the waters, – but like her in this also, 'LO, IN HER MOUTH WAS AN OLIVE BRANCH, PLUCKED OFF.'

The fourth essential element of the Gothic mind was above stated to be the sense of the GROTESQUE; but I shall defer the endeavour to define this most curious and subtle character until we have occasion to examine one of the divisions of the Renaissance schools, which was morbidly influenced by it. It is the less necessary to insist upon it here, because every reader familiar with Gothic architecture must understand what I mean, and will, I believe, have no hesitation in admitting, that the tendency to delight in fantastic and ludicrous, as well as in

sublime, images, is a universal instinct of the Gothic imagination.

The fifth element above named was RIGIDITY; and this character I must endeavour carefully to define, for neither the word I have used, nor any other that I can think of, will express it accurately. For I mean, not merely stable, but *active* rigidity; the peculiar energy which gives tension to movement, and stiffness to resistance, which makes the fiercest lightning forked rather than curved, and the stoutest oak-branch angular rather than bending, and is as much seen in the quivering of the lance as in the glittering of the icicle.

I have before had occasion to note some manifestations of this energy or fixedness; but it must be still more attentively considered here, as it shows itself throughout the whole structure and decoration of Gothic work. Egyptian and Greek buildings stand, for the most part, by their own weight and mass, one stone passively incumbent on another; but in the Gothic vaults and traceries there is a stiffness analogous to that of the bones of a limb, or fibres of a tree; an elastic tension and communication of force from part to part, and also a studious expression of this throughout every visible line of the building. And, in like manner, the Greek and Egyptian ornament is either mere surface engraving, as if the face of the wall had been stamped with a seal, or its lines are flowing, lithe, and luxuriant; in either case, there is no expression of energy in the framework of the ornament itself. But the Gothic ornament stands out in prickly independence, and frosty fortitude, jutting into crockets, and freezing into pinnacles; here starting up into a

monster, there germinating into a blossom, anon knitting itself into a branch, alternately thorny, bossy, and bristly, or writhed into every form of nervous entanglement; but, even when most graceful, never for an instant languid, always quickset: erring, if at all, ever on the side of brusquerie.

The feelings or habits in the workman which give rise to this character in the work, are more complicated and various than those indicated by any other sculptural expression hitherto named. There is, first, the habit of hard and rapid working; the industry of the tribes of the North, quickened by the coldness of the climate, and giving an expression of sharp energy to all they do, as opposed to the languor of the Southern tribes, however much of fire there may be in the heart of that languor, for lava itself may flow languidly. There is also the habit of finding enjoyment in the signs of cold, which is never found, I believe, in the inhabitants of countries south of the Alps. Cold is to them an unredeemed evil, to be suffered and forgotten as soon as may be; but the long winter of the North forces the Goth (I mean the Englishman, Frenchman, Dane, or German), if he would lead a happy life at all, to find resources of happiness in foul weather as well as fair, and to rejoice in the leafless as well as in the shady forest. And this we do with all our hearts; finding perhaps nearly as much contentment by the Christmas fire as in the summer sunshine, and gaining health and strength on the ice-fields of winter, as well as among the meadows of spring. So that there is nothing adverse or painful to our feelings in the cramped and stiffened structure of vegetation checked by cold; and

instead of seeking, like the Southern sculpture, to express only the softness of leafage nourished in all tenderness, and tempted into all luxuriance by warm winds and glowing rays, we find pleasure in dwelling upon the crabbed, perverse, and morose animation of plants that have known little kindness from earth or heaven, but, season after season, have had their best efforts palsied by frost, their brightest buds buried under snow, and their goodliest limbs lopped by tempest.

There are many subtle sympathies and affections which join to confirm the Gothic mind in this peculiar choice of subject; and when we add to the influence of these, the necessities consequent upon the employment of a rougher material, compelling the workman to seek for vigour of effect, rather than refinement of texture or accuracy of form, we have direct and manifest causes for much of the difference between the Northern and Southern cast of conception: but there are indirect causes holding a far more important place in the Gothic heart, though less immediate in their influence on design. Strength of will, independence of character, resoluteness of purpose, impatience of undue control, and that general tendency to set the individual reason against authority, and the individual deed against destiny, which, in the Northern tribes, has opposed itself throughout all ages, to the languid submission, in the Southern, of thought to tradition, and purpose to fatality, are all more or less traceable in the rigid lines, vigorous and various masses, and daringly projecting and independent structure of the Northern Gothic ornament: while the opposite feelings are in like manner legible in the graceful and softly

guided waves and wreathed bands, in which Southern decoration is constantly disposed; in its tendency to lose its independence, and fuse itself into the surface of the masses upon which it is traced; and in the expression seen so often, in the arrangement of those masses themselves, of an abandonment of their strength to an inevitable necessity, or a listless repose.

There is virtue in the measure, and error in the excess, of both these characters of mind, and in both of the styles which they have created; the best architecture, and the best temper, are those which unite them both; and this fifth impulse of the Gothic heart is therefore that which needs most caution in its indulgence. It is more definitely Gothic than any other, but the best Gothic building is not that which is *most* Gothic: it can hardly be too frank in its confession of rudeness, hardly too rich in its changefulness, hardly too faithful in its naturalism; but it may go too far in its rigidity, and, like the great Puritan spirit in its extreme, lose itself either in frivolity of division, or perversity of purpose. It actually did so in its later times; but it is gladdening to remember that in its utmost nobleness, the very temper which has been thought most adverse to it, the Protestant spirit of self-dependence and inquiry, was expressed in its every line. Faith and aspiration there were, in every Christian ecclesiastical building, from the first century to the fifteenth; but the moral habits to which England in this age owes the kind of greatness that she has, – the habits of philosophical investigation, of accurate thought, of domestic seclusion and independence, of stern self-reliance and sincere upright searching into religious

truth, – were only traceable in the features which were the distinctive creation of the Gothic schools, in the veined foliage, and thorny fretwork, and shadowy niche, and buttressed pier, and fearless height of subtle pinnacle and crested tower, sent like an 'unperplexed question up to Heaven.'

Last, because the least essential, of the constituent elements of this noble school, was placed that of REDUNDANCE, – the uncalculating bestowal of the wealth of its labour. There is, indeed, much Gothic, and that of the best period, in which this element is hardly traceable, and which depends for its effect almost exclusively on loveliness of simple design and grace of uninvolved proportion; still, in the most characteristic buildings, a certain portion of their effect depends upon accumulation of ornament; and many of those which have most influence on the minds of men, have attained it by means of this attribute alone. And although, by careful study of the school, it is possible to arrive at a condition of taste which shall be better contented by a few perfect lines than by a whole façade covered with fretwork, the building which only satisfies such a taste is not to be considered the best. For the very first requirement of Gothic architecture being, as we saw above, that it shall both admit the aid, and appeal to the admiration, of the rudest as well as the most refined minds, the richness of the work is, paradoxical as the statement may appear, a part of its humility. No architecture is so haughty as that which is simple; which refuses to address the eye, except in a few clear and forceful lines; which implies, in offering so little to our regards, that all it has

offered is perfect; and disdains, either by the complexity or the attractiveness of its features, to embarrass our investigation, or betray us into delight. That humility, which is the very life of the Gothic school, is shown not only in the imperfection, but in the accumulation, of ornament. The inferior rank of the workman is often shown as much in the richness, as the roughness, of his work; and if the co-operation of every hand, and the sympathy of every heart, are to be received, we must be content to allow the redundance which disguises the failure of the feeble, and wins the regard of the inattentive. There are, however, far nobler interests mingling, in the Gothic heart, with the rude love of decorative accumulation: a magnificent enthusiasm, which feels as if it never could do enough to reach the fulness of its ideal; an unselfishness of sacrifice, which would rather cast fruitless labour before the altar than stand idle in the market; and, finally, a profound sympathy with the fulness and wealth of the material universe, rising out of that Naturalism whose operation we have already endeavoured to define. The sculptor who sought for his models among the forest leaves, could not but quickly and deeply feel that complexity need not involve the loss of grace, nor richness that of repose; and every hour which he spent in the study of the minute and various work of Nature, made him feel more forcibly the barrenness of what was best in that of man: nor is it to be wondered at, that, seeing her perfect and exquisite creations poured forth in a profusion which conception could not grasp nor calculation sum, he should think that it ill became him to be niggardly of his own rude

craftsmanship; and where he saw throughout the universe a faultless beauty lavished on measureless spaces of broidered field and blooming mountain, to grudge his poor and imperfect labour to the few stones that he had raised one upon another, for habitation or memorial. The years of his life passed away before his task was accomplished; but generation succeeded generation with unwearied enthusiasm, and the cathedral front was at last lost in the tapestry of its traceries, like a rock among the thickets and herbage of spring.

We have now, I believe, obtained a view approaching to completeness of the various moral or imaginative elements which composed the inner spirit of Gothic architecture [. . .]

The Work of Iron, in Nature, Art, and Policy

A Lecture delivered at Tunbridge Wells,
February 16th, 1858

WHEN first I heard that you wished me to address you
this evening, it was a matter of some doubt with me
whether I could find any subject that would possess any
sufficient interest for you to justify my bringing you out
of your comfortable houses on a winter's night. When I
venture to speak about my own special business of art,
it is almost always before students of art, among whom
I may sometimes permit myself to be dull, if I can feel
that I am useful: but a mere talk about art, especially
without examples to refer to (and I have been unable to
prepare any careful illustrations for this lecture), is sel-
dom of much interest to a general audience. As I was
considering what you might best bear with me in speak-
ing about, there came naturally into my mind a subject
connected with the origin and present prosperity of
the town you live in; and, it seemed to me, in the
outbranchings of it, capable of a very general interest.
When, long ago (I am afraid to think how long), Tun-
bridge Wells was my Switzerland, and I used to be
brought down here in the summer, a sufficiently active
child, rejoicing in the hope of clambering sandstone cliffs
of stupendous height above the common, there used

sometimes, as, I suppose, there are in the lives of all children at the Wells, to be dark days in my life – days of condemnation to the pantiles and band – under which calamities my only consolation used to be in watching, at every turn in my walk, the welling forth of the spring over the orange rim of its marble basin. The memory of the clear water, sparkling over its saffron stain, came back to me as the strongest image connected with the place; and it struck me that you might not be unwilling, to-night, to think a little over the full significance of that saffron stain, and of the power, in other ways and other functions, of the steely element to which so many here owe returning strength and life; – chief as it has been always, and is yet more and more markedly so day by day, among the precious gifts of the earth.

The subject is, of course, too wide to be more than suggestively treated; and even my suggestions must be few, and drawn chiefly from my own fields of work; nevertheless, I think I shall have time to indicate some courses of thought which you may afterwards follow out for yourselves if they interest you; and so I will not shrink from the full scope of the subject which I have announced to you – the functions of Iron, in Nature, Art, and Policy.

Without more preface, I will take up the first head.

I. Iron in Nature. – You all probably know that the ochreous stain, which, perhaps, is often thought to spoil the basin of your spring, is iron in a state of rust: and when you see rusty iron in other places you generally think, not only that it spoils the places it stains, but that it is spoiled itself – that rusty iron is spoiled iron.

For most of our uses it generally is so; and because we cannot use a rusty knife or razor so well as a polished one, we suppose it to be a great defect in iron that it is subject to rust. But not at all. On the contrary, the most perfect and useful state of it is that ochreous stain; and therefore it is endowed with so ready a disposition to get itself into that state. It is not a fault in the iron, but a virtue, to be so fond of getting rusted, for in that condition it fulfils its most important functions in the universe, and most kindly duties to mankind. Nay, in a certain sense, and almost a literal one, we may say that iron rusted is Living; but when pure or polished, Dead. You all probably know that in the mixed air we breathe, the part of it essentially needful to us is called oxygen; and that this substance is to all animals, in the most accurate sense of the word, 'breath of life'. The nervous power of life is a different thing; but the supporting element of the breath, without which the blood, and therefore the life, cannot be nourished, is this oxygen. Now it is this very same air which the iron breathes when it gets rusty. It takes the oxygen from the atmosphere as eagerly as we do, though it uses it differently. The iron keeps all that it gets; we, and other animals, part with it again; but the metal absolutely keeps what it has once received of this aërial gift; and the ochreous dust which we so much despise is, in fact, just so much nobler than pure iron, in so far as it is *iron and the air*. Nobler, and more useful – for, indeed, as I shall be able to show you presently – the main service of this metal, and of all other metals, to us, is not in making knives, and scissors, and pokers, and pans, but in making the ground we feed

from, and nearly all the substances first needful to our existence. For these are all nothing but metals and oxygen – metals with breath put into them. Sand, lime, clay, and the rest of the earths – potash and soda, and the rest of the alkalies – are all of them metals which have undergone this, so to speak, vital change, and have been rendered fit for the service of man by permanent unity with the purest air which he himself breathes. There is only one metal which does not rust readily; and that in its influence on Man hitherto, has caused Death rather than Life; it will not be put to its right use till it is made a pavement of, and so trodden under foot.*

Is there not something striking in this fact, considered largely as one of the types, or lessons, furnished by the inanimate creation? Here you have your hard, bright, cold, lifeless metal – good enough for swords and scissors – but not for food. You think, perhaps, that your iron is wonderfully useful in a pure form, but how would you like the world, if all your meadows, instead of grass, grew nothing but iron wire – if all your arable ground, instead of being made of sand and clay, were suddenly turned into flat surfaces of steel – if the whole earth, instead of its green and glowing sphere, rich with forest and flower, showed nothing but the image of the vast furnace of a ghastly engine – a globe of black, lifeless, excoriated metal? It would be that, – probably it was once that; but assuredly it would be, were it not that all the substance of which it is made sucks and breathes the brilliancy of the atmosphere; and, as it breathes, softening

* Gold

from its merciless hardness, it falls into fruitful and beneficent dust; gathering itself again into the earths from which we feed, and the stones with which we build; – into the rocks that frame the mountains, and the sands that bind the sea.

Hence, it is impossible for you to take up the most insignificant pebble at your feet, without being able to read, if you like, this curious lesson in it. You look upon it at first as if it were earth only. Nay, it answers, 'I am not earth – I am earth and air in one; part of that blue heaven which you love, and long for, is already in me; it is all my life – without it I should be nothing, and able for nothing; I could not minister to you, nor nourish you – I should be a cruel and helpless thing; but, because there is, according to my need and place in creation, a kind of soul in me, I have become capable of good, and helpful in the circles of vitality.'

Thus far the same interest attaches to all the earths, and all the metals of which they are made; but a deeper interest and larger beneficence belong to that ochreous earth of iron which stains the marble of your springs. It stains much besides that marble. It stains the great earth wheresoever you can see it, far and wide – it is the colouring substance appointed to colour the globe for the sight, as well as subdue it to the service of man. You have just seen your hills covered with snow, and, perhaps, have enjoyed, at first, the contrast of their fair white with the dark blocks of pine woods; but have you ever considered how you would like them always white – not pure white, but dirty white – the white of thaw, with all the chill of snow in it, but none of its brightness?

That is what the colour of the earth would be without its iron; that would be its colour, not here or there only, but in all places, and at all times. Follow out that idea till you get it in some detail. Think first of your pretty gravel walks in your gardens, and fine, like plots of sunshine between the yellow flower-beds; fancy them all suddenly turned to the colour of ashes. That is what they would be without iron ochre. Think of your winding walks over the common, as warm to the eye as they are dry to the foot, and imagine them all laid down suddenly with gray cinders. Then pass beyond the common into the country, and pause at the first ploughed field that you see sweeping up hill sides in the sun, with its deep brown furrows, and wealth of ridges all a-glow, heaved aside by the ploughshare, like deep folds of a mantle of russet velvet – fancy it all changed suddenly into grisly furrows in a field of mud. That is what it would be without iron. Pass on, in fancy, over hill and dale, till you reach the bending line of the sea shore; go down upon its breezy beach – watch the white foam flashing among the amber of it, and all the blue sea embayed in belts of gold: then fancy those circlets of far sweeping shore suddenly put into mounds of mourning – all those golden sands turned into gray slime; the fairies no more able to call to each other, 'Come unto these yellow sands'; but, 'Come unto these drab sands.' That is what they would be, without iron.

Iron is in some sort, therefore, the sunshine and light of landscape, so far as that light depends on the ground; but it is a source of another kind of sunshine, quite as

important to us in the way we live at present – sunshine, not of landscape, but of dwelling-place.

In these days of swift locomotion I may doubtless assume that most of my audience have been somewhere out of England – have been in Scotland, or France, or Switzerland. Whatever may have been their impression, on returning to their own country, of its superiority or inferiority in other respects, they cannot but have felt one thing about it – the comfortable look of its towns and villages. Foreign towns are often very picturesque, very beautiful, but they never have quite that look of warm self-sufficiency and wholesome quiet with which our villages nestle themselves down among the green fields. If you will take the trouble to examine into the sources of this impression, you will find that by far the greater part of that warm and satisfactory appearance depends upon the rich scarlet colour of the bricks and tiles. It does not belong to the neat building – every neat building has an uncomfortable rather than a comfortable look – but it depends on the *warm* building; our villages are dressed in red tiles as our old women are in red cloaks; and it does not matter how warm the cloaks, or how bent and bowed the roof may be, so long as there are no holes in either one or the other, and the sobered but unextinguishable colour still glows in the shadow of the hood, and burns among the green mosses of the gable. And what do you suppose dyes your tiles of cottage roof? You don't paint them. It is Nature who puts all that lovely vermilion into the clay for you; and all that lovely vermilion is this oxide of iron. Think,

therefore, what your streets of towns would become – ugly enough, indeed, already, some of them, but still comfortable-looking – if instead of that warm brick red, the houses became all pepper-and-salt colour. Fancy your country villages changing from that homely scarlet of theirs which, in its sweet suggestion of laborious peace, is as honourable as the soldier's scarlet of laborious battle – suppose all those cottage roofs, I say, turned at once into the colour of unbaked clay, the colour of street gutters in rainy weather. That's what they would be without iron.

There is, however, yet another effect of colour in our English country towns, which, perhaps, you may not all yourselves have noticed, but for which you must take the word of a sketcher. They are not so often merely warm scarlet as they are warm purple; – a more beautiful colour still: and they owe this colour to a mingling with the vermilion of the deep grayish or purple hue of our fine Welsh slates on the more respectable roofs, made more blue still by the colour of intervening atmosphere. If you examine one of these Welsh slates freshly broken, you will find its purple colour clear and vivid; and although never strikingly so after it has been long exposed to weather, it always retains enough of the tint to give rich harmonies of distant purple in opposition to the green of our woods and fields. Whatever brightness or power there is in the hue is entirely owing to the oxide of iron. Without it the slates would either be pale stone colour, or cold gray, or black.

Thus far we have only been considering the use and pleasantness of iron in the common earth of clay. But

there are three kinds of earth which, in mixed mass and prevalent quantity, form the world. Those are, in common language, the earths of clay, of lime, and of flint. Many other elements are mingled with these in sparing quantities; but the great frame and substance of the earth is made of these three, so that wherever you stand on solid ground, in any country of the globe, the thing that is mainly under your feet will be either clay, limestone, or some condition of the earth of flint, mingled with both.

These being what we have usually to deal with, Nature seems to have set herself to make these three substances as interesting to us, and as beautiful for us, as she can. The clay, being a soft and changeable substance, she doesn't take much pains about, as we have seen, till it is baked; she brings the colour into it only when it receives a permanent form. But the limestone and flint she paints, in her own way, in their native state: and her object in painting them seems to be much the same as in her painting of flowers; to draw us, careless and idle human creatures, to watch her a little, and see what she is about – that being on the whole good for us, – her children. For Nature is always carrying on very strange work with this limestone and flint of hers: laying down beds of them at the bottom of the sea; building islands out of the sea; filling chinks and veins in mountains with curious treasures; petrifying mosses, and trees, and shells; in fact, carrying on all sorts of business, subterranean or submarine, which it would be highly desirable for us, who profit and live by it, to notice as it goes on. And apparently to lead us to do this, she makes picture-books

for us of limestone and flint; and tempts us, like foolish children as we are, to read her books by the pretty colours in them. The pretty colours in her limestone-books form those variegated marbles which all mankind have taken delight to polish and build with from the beginning of time; and the pretty colours in her flint-books form those agates, jaspers, cornelians, bloodstones, onyxes, cairngorms, chrysoprases, which men have in like manner taken delight to cut, and polish, and make ornaments of, from the beginning of time; and yet so much of babies are they, and so fond of looking at the pictures instead of reading the book, that I question whether, after six thousand years of cutting and polishing, there are above two or three people out of any given hundred who know, or care to know, how a bit of agate or a bit of marble was made, or painted.

How it was made, may not be always very easy to say; but with what it was painted there is no manner of question. All those beautiful violet veinings and variegations of the marbles of Sicily and Spain, the glowing orange and amber colours of those of Siena, the deep russet of the Rosso antico, and the blood-colour of all the precious jaspers that enrich the temples of Italy; and, finally, all the lovely transitions of tint in the pebbles of Scotland and the Rhine, which form, though not the most precious, by far the most interesting portion of our modern jewellers' work; – all these are painted by Nature with this one material only, variously proportioned and applied – the oxide of iron that stains your Tunbridge springs.

But this is not all, nor the best part of the work of

iron. Its service in producing these beautiful stones is only rendered to rich people, who can afford to quarry and polish them. But Nature paints for all the world, poor and rich together; and while, therefore, she thus adorns the innermost rocks of her hills, to tempt your investigation, or indulge your luxury, – she paints, far more carefully, the outsides of the hills, which are for the eyes of the shepherd and the ploughman. I spoke just now of the effect in the roofs of our villages of their purple slates; but if the slates are beautiful even in their flat and formal rows on house-roofs, much more are they beautiful on the rugged crests and flanks of their native mountains. Have you ever considered, in speaking as we do so often of distant blue hills, what it is that makes them blue? To a certain extent it is distance; but distance alone will not do it. Many hills look white, however distant. That lovely dark purple colour of our Welsh and Highland hills is owing, not to their distance merely, but to their rocks. Some of their rocks are, indeed, too dark to be beautiful, being black or ashy gray; owing to imperfect and porous structure. But when you see this dark colour dashed with russet and blue, and coming out in masses among the green ferns, so purple that you can hardly tell at first whether it is rock or heather, then you must thank your old Tunbridge friend, the oxide of iron.

But this is not all. It is necessary for the beauty of hill scenery that Nature should colour not only her soft rocks, but her hard ones; and she colours them with the same thing, only more beautifully. Perhaps you have wondered at my use of the word 'purple', so often of

stones; but the Greeks, and still more the Romans, who had profound respect for purple, used it of stone long ago. You have all heard of 'porphyry' as among the most precious of the harder massive stones. The colour which gave it that noble name, as well as that which gives the flush to all the rosy granite of Egypt – yes, and to the rosiest summits of the Alps themselves – is still owing to the same substance – your humble oxide of iron.

And last of all:

A nobler colour than all these – the noblest colour ever seen on this earth – one which belongs to a strength greater than that of the Egyptian granite, and to a beauty greater than that of the sunset or the rose – is still mysteriously connected with the presence of this dark iron. I believe it is not ascertained on what the crimson of blood actually depends; but the colour is connected, of course, with its vitality, and that vitality with the existence of iron as one of its substantial elements.

Is it not strange to find this stern and strong metal mingled so delicately in our human life that we cannot even blush without its help? Think of it, my fair and gentle hearers; how terrible the alternative – sometimes you have actually no choice but to be brazen-faced, or iron-faced!

In this slight review of some of the functions of the metal, you observe that I confine myself strictly to its operations as a colouring element. I should only confuse your conception of the facts if I endeavoured to describe its uses as a substantial element, either in strengthening rocks or influencing vegetation by the decomposition of rocks. I have not, therefore, even glanced at any of the

more serious uses of the metal in the economy of nature. But what I wish you to carry clearly away with you is the remembrance that in all these uses the metal would be nothing without the air. The pure metal has no power, and never occurs in nature at all, except in meteoric stones, whose fall no one can account for, and which are useless after they have fallen: in the necessary work of the world, the iron is invariably joined with the oxygen, and would be capable of no service or beauty whatever without it.

II. Iron in Art. – Passing, then, from the offices of the metal in the operations of nature to its uses in the hands of man, you must remember, in the outset, that the type which has been thus given you, by the lifeless metal, of the action of body and soul together, has noble antitype in the operation of all human power. All art worthy the name is the energy – neither of the human body alone, nor of the human soul alone, but of both united, one guiding the other: good craftsmanship and work of the fingers joined with good emotion and work of the heart.

There is no good art, nor possible judgment of art, when these two are not united; yet we are constantly trying to separate them. Our amateurs cannot be persuaded but that they may produce some kind of art by their fancy or sensibility, without going through the necessary manual toil. That is entirely hopeless. Without a certain number, and that a very great number, of steady acts of hand – a practice as careful and constant as would be necessary to learn any other manual business – no drawing is possible. On the other side, the workman,

and those who employ him, are continually trying to produce art by trick or habit of fingers, without using their fancy or sensibility. That also is hopeless. Without mingling of heart-passion with hand-power, no art is possible. The highest art unites both in their intensest degrees: the action of the hand at its finest, with that of the heart at its fullest.

Hence it follows that the utmost power of art can only be given in a material capable of receiving and retaining the influence of the subtlest touch of the human hand. That hand is the most perfect agent of material power existing in the universe; and its full subtlety can only be shown when the material it works on, or with, is entirely yielding. The chords of a perfect instrument will receive it, but not of an imperfect one; the softly-bending point of the hair pencil, and soft melting of colour, will receive it, but not even the chalk or pen point, still less the steel point, chisel, or marble. The hand of a sculptor may, indeed, be as subtle as that of a painter, but all its subtlety is not bestowable nor express-ible: the touch of Titian, Correggio, or Turner is a far more marvellous piece of nervous action than can be shown in anything but colour, or in the very highest conditions of executive expression in music. In pro-portion as the material worked upon is less delicate, the execution necessarily becomes lower, and the art with it. This is one main principle of all work. Another is, that whatever the material you choose to work with, your art is base if it does not bring out the distinctive qualities of that material.

The reason of this second law is, that if you don't

want the qualities of the substance you use, you ought to use some other substance: it can be only affectation, and desire to display your skill, that lead you to employ a refractory substance, and therefore your art will all be base. Glass, for instance, is eminently, in its nature, transparent. If you don't want transparency, let the glass alone. Do not try to make a window look like an opaque picture, but take an opaque ground to begin with. Again, marble is eminently a solid and massive substance. Unless you want mass and solidity, don't work in marble. If you wish for lightness, take wood; if for freedom, take stucco; if for ductility, take glass. Don't try to carve feathers, or trees, or nets, or foam, out of marble. Carve white limbs and broad breasts only out of that.

So again, iron is eminently a ductile and tenacious substance – tenacious above all things, ductile more than most. When you want tenacity, therefore, and involved form, take iron. It is eminently made for that. It is the material given to the sculptor as the companion of marble, with a message, as plain as it can well be spoken, from the lips of the earth-mother, 'Here's for you to cut, and here's for you to hammer. Shape this, and twist that. What is solid and simple, carve out; what is thin and entangled, beat out. I give you all kinds of forms to be delighted in; fluttering leaves as well as fair bodies; twisted branches as well as open brows. The leaf and the branch you may beat and drag into their imagery: the body and brow you shall reverently touch into their imagery. And if you choose rightly and work rightly, what you do shall be safe afterwards. Your slender leaves shall not break off in my tenacious iron, though they

may be rusted a little with an iron autumn. Your broad surfaces shall not be unsmoothed in my pure crystalline marble – no decay shall touch them. But if you carve in the marble what will break with a touch, or mould in the metal what a stain of rust or verdigris will spoil, it is your fault – not mine.'

These are the main principles in this matter; which, like nearly all other right principles in art, we moderns delight in contradicting as directly and specially as may be. We continually look for, and praise, in our exhibitions, the sculpture of veils, and lace, and thin leaves, and all kinds of impossible things pushed as far as possible in the fragile stone, for the sake of showing the sculptor's dexterity.* On the other hand, we *cast* our iron into bars – brittle, though an inch thick – sharpen them at the ends, and consider fences, and other work, made of such materials, decorative! I do not believe it would be easy to calculate the amount of mischief done to our taste in England by that fence ironwork of ours alone. If it were asked of us, by a single characteristic, to distinguish the dwellings of a country into two broad sections; and

* I do not mean to attach any degree of blame to the effort to represent leafage in marble for certain expressive purposes. The later works of Mr Munro have depended for some of their most tender thoughts on a delicate and skilful use of such accessories. And in general, leaf sculpture is good and admirable, if it renders, as in Gothic work, the grace and lightness of the leaf by the arrangement of light and shadow – supporting the masses well by strength of stone below; but all carving is base which proposes to itself *slightness* as an aim, and tries to imitate the absolute thinness of thin or slight things, as much modern wood-carving does. I saw in Italy, a year or two ago, a marble sculpture of birds' nests.

to set, on one side, the places where people were, for the most part, simple, happy, benevolent, and honest; and, on the other side, the places where at least a great number of the people were sophisticated, unkind, uncomfortable, and unprincipled, there is, I think, one feature that you could fix upon as a positive test: the uncomfortable and unprincipled parts of a country would be the parts where people lived among iron railings, and the comfortable and principled parts where they had none. A broad generalization, you will say! Perhaps a little too broad; yet, in all sobriety, it will come truer than you think. Consider every other kind of fence or defence, and you will find some virtue in it; but in the iron railing, none. There is, first, your castle rampart of stone – somewhat too grand to be considered here among our types of fencing; next, your garden or park wall of brick, which has indeed often an unkind look on the outside, but there is more modesty in it than unkindness. It generally means, not that the builder of it wants to shut you out from the view of his garden, but from the view of himself: it is a frank statement that as he needs a certain portion of time to himself, so he needs a certain portion of ground to himself, and must not be stared at when he digs there in his shirt-sleeves, or plays at leapfrogs with his boys from school, or talks over old times with his wife, walking up and down in the evening sunshine. Besides, the brick wall has good practical service in it, and shelters you from the east wind, and ripens your peaches and nectarines, and glows in autumn like a sunny bank. And, moreover, your brick wall, if you build it properly, so that it shall stand long enough, is a

beautiful thing when it is old, and has assumed its grave purple red, touched with mossy green.

Next to your lordly wall, in dignity of enclosure, comes your close-set wooden paling, which is more objectionable, because it commonly means enclosure on a larger scale than people want. Still it is significative of pleasant parks, and well-kept field walks, and herds of deer, and other such aristocratic pastoralisms, which have here and there their proper place in a country, and may be passed without any discredit.

Next to your paling comes your low stone dyke, your mountain fence, indicative at a glance either of wild hill country, or of beds of stone beneath the soil; the hedge of the mountains – delightful in all its associations, and yet more in the varied and craggy forms of the loose stones it is built of: and next to the low stone wall, your lowland hedge, either in trim line of massive green, suggestive of the pleasances of old Elizabethan houses, and smooth alleys for aged feet, and quaint labyrinths for young ones, or else in fair entanglement of eglantine and virgin's bower, tossing its scented luxuriance along our country waysides: – how many such you have here among your pretty hills, fruitful with black clusters of the bramble for boys in autumn, and crimson hawthorn-berries for birds in winter. And then last, and most difficult to class among fences, comes your hand-rail, expressive of all sorts of things; sometimes having a knowing and vicious look, which it learns at race-courses; sometimes an innocent and tender look, which it learns at rustic bridges over cressy brooks; and sometimes a prudent and protective look, which it learns on passes of

the Alps, where it has posts of granite and bars of pine, and guards the brows of cliffs and the banks of torrents. So that in all these kinds of defence there is some good, pleasant, or noble meaning. But what meaning has the iron railing? Either, observe, that you are living in the midst of such bad characters that you must keep them out by main force of bar, or that you are yourself of a character requiring to be kept inside in the same manner. Your iron railing always means thieves outside, or Bedlam inside; – it *can* mean nothing else than that. If the people outside were good for anything, a hint in the way of fence would be enough for them; but because they are violent and at enmity with you, you are forced to put the close bars and the spikes at the top. Last summer I was lodging for a little while in a cottage in the country, and in front of my low window there were, first, some beds of daisies, then a row of gooseberry and currant bushes, and then a low wall about three feet above the ground, covered with stone-cress; outside, a cornfield, with its green ears glistening in the sun, and a field path through it, just past the garden gate. From my window I could see every peasant of the village who passed that way, with basket on arm for market, or spade on shoulder for field. When I was inclined for society, I could lean over my wall, and talk to anybody; when I was inclined for science, I could botanize all along the top of my wall – there were four species of stone-cress alone growing on it; and when I was inclined for exercise, I could jump over my wall, backwards and forwards. That's the sort of fence to have in a Christian country; not a thing which you can't walk inside of without

making yourself look like a wild beast, nor look at out of your window in the morning without expecting to see somebody impaled upon it in the night.

And yet farther, observe that the iron railing is a useless fence – it can shelter nothing, and support nothing; you can't nail your peaches to it, nor protect your flowers with it, nor make anything whatever out of its costly tyranny; and besides being useless, it is an insolent fence; – it says plainly to everybody who passes – 'You may be an honest person, – but, also, you may be a thief: honest or not, you shall not get in here, for I am a respectable person and much above you; you shall only see what a grand place I have got to keep you out of – look here, and depart in humiliation.'

This, however, being in the present state of civilization a frequent manner of discourse, and there being unfortunately many districts where the iron railing is unavoidable, it yet remains a question whether you need absolutely make it ugly, no less than significative of evil. You must have railings round your squares in London, and at the sides of your areas; but need you therefore have railings so ugly that the constant sight of them is enough to neutralise the effect of all the schools of art in the kingdom? You need not. Far from such necessity, it is even in your power to turn all your police force of iron bars actually into drawing masters, and natural historians. Not, of course, without some trouble and some expense; you can do nothing much worth doing, in this world, without trouble, you can get nothing much worth having, without expense. The main question is only – what is worth doing and having: – Consider,

therefore, if this is not. Here is your iron railing, as yet, an uneducated monster; a sombre seneschal, incapable of any words, except his perpetual 'Keep out!' and 'Away with you!' Would it not be worth some trouble and cost to turn this ungainly ruffian porter into a well-educated servant; who, while he was severe as ever in forbidding entrance to evilly disposed people, should yet have a kind word for well-disposed people, and a pleasant look, and a little useful information at his command, in case he should be asked a question by the passers-by?

We have not time to-night to look at many examples of ironwork; and those I happen to have by me are not the best; ironwork is not one of my special subjects of study; so that I only have memoranda of bits that happened to come into picturesque subjects which I was drawing for other reasons. Besides, external ironwork is more difficult to find good than any other sort of ancient art; for when it gets rusty and broken, people are sure, if they can afford it, to send it to the old iron shop, and get a fine new grating instead; and in the great cities of Italy the old iron is thus nearly all gone: the best bits I remember in the open air were at Brescia; – fantastic sprays of laurel-like foliage rising over the garden gates; and there are a few fine fragments at Verona, and some good trellis-work enclosing the Scala tombs; but on the whole, the most interesting pieces, though by no means the purest in style, are to be found in out-of-the-way provincial towns, where people do not care, or are unable, to make polite alterations. The little town of Bellinzona, for instance, on the south of the Alps, and that of Sion on the north, have both of them complete

schools of ironwork in their balconies and vineyard gates. That of Bellinzona is the best, though not very old – I suppose most of it of the seventeenth century; still it is very quaint and beautiful. Here, for example, are two balconies, from two different houses: one has been a cardinal's, and the hat is the principal ornament of the balcony, its tassels being wrought with delightful delicacy and freedom; and catching the eye clearly even among the mass of rich wreathed leaves. These tassels and strings are precisely the kind of subject fit for ironwork – noble in ironwork, they would have been entirely ignoble in marble, on the grounds above stated. The real plant of oleander standing in the window enriches the whole group of lines very happily.

The other balcony, from a very ordinary-looking house in the same street, is much more interesting in its details. It appeared last summer with convolvulus twined about the bars, the arrow-shaped living leaves mingled among the leaves of iron [. . .] It is composed of a large tulip in the centre; then two turkscap lilies; then two pinks, a little conventionalized; then two narcissi; then two nondescripts, or, at least, flowers I do not know; and then two dark buds, and a few leaves; I say *dark* buds, for all these flowers have been coloured in their original state. The plan of the group is exceedingly simple: it is all enclosed in a pointed arch, the large mass of the tulip forming the apex; a six-foiled star on each side; then a jagged star; then a five-foiled star; then an unjagged star or rose; finally a small bud, so as to establish relation and cadence through the whole group. The profile is very free and fine, and the upper bar of the

balcony exceedingly beautiful in effect; – none the less so on account of the marvellously simple means employed. A thin strip of iron is bent over a square rod; out of the edge of this strip are cut a series of triangular openings – widest at top, leaving projecting teeth of iron; then each of these projecting pieces gets a little sharp tap with the hammer in front, which breaks its edge inwards, tearing it a little open at the same time, and the thing is done.

The common forms of Swiss ironwork are less naturalistic than these Italian balconies, depending more on beautiful arrangements of various curve; nevertheless there has been a rich naturalist school at Fribourg, where a few bell-handles are still left, consisting of rods branched into laurel and other leafage. At Geneva, modern improvements have left nothing; but at Annecy a little good work remains; the balcony of its old hôtel de ville especially, with a trout of the lake – presumably the town arms – forming its central ornament.

I might expatiate all night – if you would sit and hear me – on the treatment of such required subject, or introduction of pleasant caprice by the old workmen; but we have no more time to spare, and I must quit this part of our subject – the rather as I could not explain to you the intrinsic merit of such ironwork without going fully into the theory of curvilinear design; only let me leave with you this one distinct assertion – that the quaint beauty and character of many natural objects, such as intricate branches, grass, foliage (especially thorny branches and prickly foliage), as well as that of many animals, plumed, spined, or bristled, is sculpturally

expressible in iron only, and in iron would be majestic and impressive in the highest degree; and that every piece of metal work you use might be, rightly treated, not only a superb decoration, but a most valuable abstract of portions of natural forms, holding in dignity precisely the same relation to the painted representation of plants that a statue does to the painted form of man. It is difficult to give you an idea of the grace and interest which the simplest objects possess when their forms are thus abstracted from among the surrounding of rich circumstance which in nature disturbs the feebleness of our attention. Every cluster of herbage would furnish fifty such groups, and every such group would work into iron (fitting it, of course, rightly to its service) with perfect ease, and endless grandeur of result.

III. IRON IN POLICY. – Having thus obtained some idea of the use of iron in art, as dependent on its ductility, I need not, certainly, say anything of its uses in manufacture and commerce; we all of us know enough – perhaps a little too much – about *them*. So I pass lastly to consider its uses in policy; dependent chiefly upon its tenacity – that is to say, on its power of bearing a pull, and receiving an edge. These powers, which enable it to pierce, to bind, and to smite, render it fit for the three great instruments by which its political action may be simply typified; namely, the Plough, the Fetter, and the Sword.

On our understanding the right use of these three instruments depends, of course, all our power as a nation, and all our happiness as individuals.

(1) THE PLOUGH. – I say, first, on our understanding the right use of the plough, with which, in justice to the

fairest of our labourers, we must always associate that feminine plough – the needle. The first requirement for the happiness of a nation is that it should understand the function in this world of these two great instruments: a happy nation may be defined as one in which the husband's hand is on the plough, and the housewife's on the needle; so in due time reaping its golden harvest, and shining in golden vesture: and an unhappy nation is one which, acknowledging no use of plough nor needle, will assuredly at last find its storehouse empty in the famine, and its breast naked to the cold.

Perhaps you think this is a mere truism, which I am wasting your time in repeating. I wish it were.

By far the greater part of the suffering and crime which exist at this moment in civilized Europe, arises simply from people not understanding this truism – not knowing that produce or wealth is eternally connected by the laws of heaven and earth with resolute labour; but hoping in some way to cheat or abrogate this everlasting law of life, and to feed where they have not furrowed, and be warm where they have not woven.

I repeat, nearly all our misery and crime result from this one misapprehension. The law of nature is, that a certain quantity of work is necessary to produce a certain quantity of good, of any kind whatever. If you want knowledge, you must toil for it: if food, you must toil for it: and if pleasure, you must toil for it. But men do not acknowledge this law; or strive to evade it, hoping to get their knowledge, and food, and pleasure for nothing: and in this effort they either fail of getting them, and remain ignorant and miserable, or they obtain them by

making other men work for their benefit; and then they are tyrants and robbers. Yes, and worse than robbers. I am not one who in the least doubts or disputes the progress of this century in many things useful to mankind; but it seems to me a very dark sign respecting us that we look with so much indifference upon dishonesty and cruelty in the pursuit of wealth. In the dream of Nebuchadnezzar, it was only the *feet* that were part of iron and part of clay, but many of us are now getting so cruel in our avarice that it seems as if, in us, the *heart* were part of iron, part of clay.

From what I have heard of the inhabitants of this town, I do not doubt but that I may be permitted to do here what I have found it usually thought elsewhere highly improper and absurd to do, namely, trace a few Bible sentences to their practical result.

You cannot but have noticed how often in those parts of the Bible which are likely to be oftenest opened when people look for guidance, comfort, or help in the affairs of daily life, – namely, the Psalms and Proverbs, – mention is made of the guilt attaching to the *Oppression* of the poor. Observe: not the neglect of them, but the *Oppression* of them: the word is as frequent as it is strange. You can hardly open either of those books, but somewhere in their pages you will find a description of the wicked man's attempts against the poor: such as, – 'He doth ravish the poor when he getteth him into his net.'

'He sitteth in the lurking places of the villages; his eyes are privily set against the poor.'

'In his pride he doth persecute the poor, and blesseth the covetous, whom God abhorreth.'

'His mouth is full of deceit and fraud; in the secret places doth he murder the innocent. Have the workers of iniquity no knowledge, who eat up my people as they eat bread? They have drawn out the sword, and bent the bow, to cast down the poor and needy.'

'They are corrupt, and speak wickedly concerning oppression.'

'Pride compasseth them about as a chain, and violence as a garment.'

'Their poison is like the poison of a serpent. Ye weigh the violence of your hands in the earth.'

Yes: 'Ye weigh the violence of your hands:' – weigh these words as well. The last things we ever usually think of weighing are Bible words. We like to dream and dispute over them; but to weigh them, and see what their true contents are – anything but that. Yet, weigh these; for I have purposely taken all these verses, perhaps more striking to you read in this connection than separately in their places, out of the Psalms, because, for all people belonging to the Established Church of this country, these Psalms are appointed lessons, portioned out to them by their clergy to be read once through every month. Presumably, therefore, whatever portions of Scripture we may pass by or forget, these, at all events, must be brought continually to our observance as useful for direction of daily life. Now, do we ever ask ourselves what the real meaning of these passages may be, and who these wicked people are, who are 'murdering the innocent'? You know it is rather singular language, this! – rather strong language, we might, perhaps, call it – hearing it for the first time. Murder! and murder of

innocent people! – nay, even a sort of cannibalism. Eating people, – yes, and God's people, too – eating *My* people as if they were bread! swords drawn, bows bent, poison of serpents mixed! violence of hands weighed, measured, and trafficked with as so much coin! – where is all this going on? Do you suppose it was only going on in the time of David, and that nobody but Jews ever murder the poor? If so, it would surely be wiser not to mutter and mumble for our daily lessons what does not concern us; but if there be any chance that it may concern us, and if this description, in the Psalms, of human guilt is at all generally applicable, as the descriptions in the Psalms of human sorrow are, may it not be advisable to know wherein this guilt is being committed round about us, or by ourselves? and when we take the words of the Bible into our mouths in a congregational way, to be sure whether we mean merely to chant a piece of melodious poetry relating to other people – (we know not exactly to whom) – or to assert our belief in facts bearing somewhat stringently on ourselves and our daily business. And if you make up your minds to do this no longer, and take pains to examine into the matter, you will find that these strange words, occurring as they do, not in a few places only, but almost in every alternate psalm and every alternate chapter of proverb or prophecy, with tremendous reiteration, were not written for one nation or one time only, but for all nations and languages, for all places and all centuries; and it is as true of the wicked man now as ever it was of Nabal or Dives, that 'his eyes are set against the poor.'

Set *against* the poor, mind you. Not merely set *away*

from the poor, so as to neglect or lose sight of them, but set against, so as to afflict and destroy them. This is the main point I want to fix your attention upon. You will often hear sermons about neglect or carelessness of the poor. But neglect and carelessness are not at all the points. The Bible hardly ever talks about neglect of the poor. It always talks of *oppression* of the poor – a very different matter. It does not merely speak of passing by on the other side, and binding up no wounds, but of drawing the sword and ourselves smiting the men down. It does not charge us with being idle in the pest-house, and giving no medicine, but with being busy in the pest-house, and giving much poison.

May we not advisedly look into this matter a little, even to-night, and ask first, Who are these poor?

No country is, or ever will be, without them: that is to say, without the class which cannot, on the average, do more by its labour than provide for its subsistence, and which has no accumulations of property laid by on any considerable scale. Now there are a certain number of this class whom we cannot oppress with much severity. An able-bodied and intelligent workman – sober, honest, and industrious, – will almost always command a fair price for his work, and lay by enough in a few years to enable him to hold his own in the labour market. But all men are not able-bodied, nor intelligent, nor industrious; and you cannot expect them to be. Nothing appears to me at once more ludicrous and more melancholy than the way the people of the present age usually talk about the morals of labourers. You hardly ever address a labouring man upon his prospects in life,

without quietly assuming that he is to possess, at starting, as a small moral capital to begin with, the virtue of Socrates, the philosophy of Plato, and the heroism of Epaminondas. 'Be assured, my good man,' – you say to him, – 'that if you work steadily for ten hours a day all your life long, and if you drink nothing but water, or the very mildest beer, and live on very plain food, and never lose your temper, and go to church every Sunday, and always remain content in the position in which Providence has placed you, and never grumble, nor swear; and always keep your clothes decent, and rise early, and use every opportunity of improving yourself, you will get on very well, and never come to the parish.'

All this is exceedingly true; but before giving the advice so confidently, it would be well if we sometimes tried it practically ourselves, and spent a year or so at some hard manual labour, not of an entertaining kind – ploughing or digging, for instance, with a very moderate allowance of beer; nothing but bread and cheese for dinner; no papers nor muffins in the morning; no sofas nor magazines at night; one small room for parlour and kitchen; and a large family of children always in the middle of the floor. If we think we could, under these circumstances, enact Socrates, or Epaminondas, entirely to our own satisfaction, we shall be somewhat justified in requiring the same behaviour from our poorer neighbours; but if not, we should surely consider a little whether among the various forms of the oppression of the poor, we may not rank as one of the first and likeliest – the oppression of expecting too much from them.

But let this pass; and let it be admitted that we never

can be guilty of oppression towards the sober, industrious, intelligent, exemplary labourer. There will always be in the world some who are not altogether intelligent and exemplary; we shall, I believe, to the end of time find the majority somewhat unintelligent, a little inclined to be idle, and occasionally, on Saturday night, drunk; we must even be prepared to hear of reprobates who like skittles on Sunday morning better than prayers; and of unnatural parents who send their children out to beg instead of to go to school.

Now these are the kind of people whom you *can* oppress, and whom you do oppress, and that to purpose, – and with all the more cruelty and the greater sting, because it is just their own fault that puts them into your power. You know the words about wicked people are, 'He doth ravish the poor when he getteth him *into his net.*' This getting into the net is constantly the fault or folly of the sufferer – his own heedlessness or his own indolence; but after he is once in the net, the oppression of him, and making the most of his distress, are ours. The nets which we use against the poor are just those worldly embarrassments which either their ignorance or their improvidence are almost certain at some time or other to bring them into: then, just at the time when we ought to hasten to help them, and disentangle them, and teach them how to manage better in future, we rush forward to *pillage* them, and force all we can out of them in their adversity. For, to take one instance only, remember this is literally and simply what we do, whenever we buy, or try to buy, cheap goods – goods offered at a price which we know cannot be remunerative for

the labour involved in them. Whenever we buy such goods, remember we are stealing somebody's labour. Don't let us mince the matter. I say, in plain Saxon, STEALING – taking from him the proper reward of his work, and putting it into our own pocket. You know well enough that the thing could not have been offered you at that price, unless distress of some kind had forced the producer to part with it. You take advantage of this distress, and you force as much out of him as you can under the circumstances. The old barons of the Middle Ages used, in general, the thumbscrew to extort property; we moderns use, in preference, hunger, or domestic affliction: but the fact of extortion remains precisely the same. Whether we force the man's property from him by pinching his stomach, or pinching his fingers, makes some difference anatomically; – morally, none whatsoever: we use a form of torture of some sort in order to make him give up his property; we use, indeed, the man's own anxieties, instead of the rack; and his immediate peril of starvation, instead of the pistol at the head; but otherwise we differ from Front de Bœuf, or Dick Turpin, merely in being less dexterous, more cowardly, and more cruel. More cruel, I say, because the fierce baron and the redoubted highwayman are reported to have robbed, at least by preference, only the rich; *we* steal habitually from the poor. We buy our liveries, and gild our prayer-books, with pilfered pence out of children's and sick men's wages, and thus ingeniously dispose a given quantity of Theft, so that it may produce the largest possible measure of delicately-distributed suffering.

But this is only one form of common oppression of the poor – only one way of taking our hands off the Plough-handle, and binding another's upon it. The first way of doing it is the economical way – the way preferred by prudent and virtuous people. The bolder way is the acquisitive way: – the way of speculation. You know we are considering at present the various modes in which a nation corrupts itself, by not acknowledging the eternal connection between its plough and its pleasure; – by striving to get pleasure, without working for it. Well, I say the first and commonest way of doing so is to try to get the product of other people's work, and enjoy it ourselves, by cheapening their labour in times of distress; then the second way is that grand one of watching the chances of the market; – the way of speculation. Of course there are some speculations that are fair and honest – speculations made with our own money, and which do not involve in their success the loss, by others, of what we gain. But generally modern speculation involves much risk to others, with chance of profit only to ourselves; even in its best conditions it is merely one of the forms of gambling or treasure-hunting: it is either leaving the steady plough and the steady pilgrimage of life, to look for silver mines beside the way; or else it is the full stop beside the dice-tables in Vanity Fair – investing all the thoughts and passions of the soul in the fall of the cards, and choosing rather the wild accidents of idle fortune than the calm and accumulative rewards of toil. And this is destructive enough, at least to our peace and virtue. But it is usually destructive of far more than *our* peace, or *our* virtue. Have you ever deliberately

set yourselves to imagine and measure the suffering, the guilt, and the mortality caused necessarily by the failure of any large-dealing merchant, or largely-branched bank? Take it at the lowest possible supposition – count, at the fewest you choose, the families whose means of support have been involved in the catastrophe. Then, on the morning after the intelligence of ruin, let us go forth amongst them in earnest thought; let us use that imagination which we waste so often on fictitious sorrow, to measure the stern facts of that multitudinous distress; strike open the private doors of their chambers, and enter silently into the midst of the domestic misery; look upon the old men, who had reserved for their failing strength some remainder of rest in the evening-tide of life, cast helplessly back into its trouble and tumult; look upon the active strength of middle age suddenly blasted into incapacity – its hopes crushed, and its hardly-earned rewards snatched away in the same instant – at once the heart withered, and the right arm snapped; look upon the piteous children, delicately nurtured, whose soft eyes, now large with wonder at their parents' grief, must soon be set in the dimness of famine; and, far more than all this, look forward to the length of sorrow beyond – to the hardest labour of life, now to be undergone either in all the severity of unexpected and inexperienced trial, or else, more bitter still, to be begun again, and endured for the second time, amidst the ruins of cherished hopes and the feebleness of advancing years, embittered by the continual sting and taunt of the inner feeling that it has all been brought about, not by the fair course of appointed circumstance, but by miserable chance and wanton

treachery; and, last of all, look beyond this – to the shattered destinies of those who have faltered under the trial, and sunk past recovery to despair. And then consider whether the hand which has poured this poison into all the springs of life be one whit less guiltily red with human blood than that which literally pours the hemlock into the cup, or guides the dagger to the heart? We read with horror of the crimes of a Borgia or a Tophana; but there never lived Borgias such as live now in the midst of us. The cruel lady of Ferrara slew only in the strength of passion – she slew only a few, those who thwarted her purposes or who vexed her soul; she slew sharply and suddenly, embittering the fate of her victims with no foretastes of destruction, no prolongations of pain; and, finally and chiefly, she slew not without remorse nor without pity. But *we*, in no storm of passion, – in no blindness of wrath, – we, in calm and clear and untempted selfishness, pour our poison – not for a few only, but for multitudes; – not for those who have wronged us, or resisted, – but for those who have trusted us and aided; – we, not with sudden gift of merciful and unconscious death, but with slow waste of hunger and weary rack of disappointment and despair! – we, lastly and chiefly, do our murdering, not with any pauses of pity or scorching of conscience, but in facile and forgetful calm of mind – and so, forsooth, read day by day, complacently, as if they meant any one else than ourselves, the words that for ever describe the wicked: 'The *poison of asps* is under their lips, and their *feet are swift to shed blood.*'

You may indeed, perhaps, think there is some excuse

for many in this matter, just because the sin is so uncon-
scious; that the guilt is not so great when it is unappre-
hended, and that it is much more pardonable to slay
heedlessly than purposefully. I believe no feeling can be
more mistaken; and that in reality, and in the sight of
heaven, the callous indifference which pursues its own
interests at any cost of life, though it does not definitely
adopt the purpose of sin, is a state of mind at once more
heinous and more hopeless than the wildest aberrations
of ungoverned passion. There may be, in the last case,
some elements of good and of redemption still mingled
in the character; but, in the other, few or none. There
may be hope for the man who has slain his enemy in
anger; – hope even for the man who has betrayed his
friend in fear; but what hope for him who trades in
unregarded blood, and builds his fortune on unrepented
treason?

But, however this may be, and wherever you may
think yourselves bound in justice to impute the greater
sin, be assured that the question is one of responsibilities
only, not of facts. The definite result of all our modern
haste to be rich is assuredly, and constantly, the murder
of a certain number of persons by our hands every year.
I have not time to go into the details of another – on the
whole, the broadest and terriblest way in which we cause
the destruction of the poor – namely, the way of luxury
and waste, destroying, in improvidence, what might
have been the support of thousands; but if you follow
out the subject for yourselves at home – and what I have
endeavoured to lay before you to-night will only be
useful to you if you do – you will find that wherever and

whenever men are endeavouring to *make money hastily*, and to avoid the labour which Providence has appointed to be the only source of honourable profit; – and also wherever and whenever they permit themselves to *spend it luxuriously*, without reflecting how far they are misguiding the labour of others; – there and then, in either case, they are literally and infallibly causing, for their own benefit or their own pleasure, a certain annual number of human deaths; that, therefore, the choice given to every man born into this world is, simply, whether he will be a labourer or an assassin; and that whosoever has not his hand on the Stilt of the plough, has it on the Hilt of the dagger.

It would also be quite vain for me to endeavour to follow out this evening the lines of thought which would be suggested by the other two great political uses of iron in the Fetter and the Sword: a few words only I must permit myself respecting both.

(2) THE FETTER. – As the plough is the typical instrument of industry, so the fetter is the typical instrument of the restraint or subjection necessary in a nation – either literally, for its evildoers, or figuratively, in accepted laws, for its wise and good men. You have to choose between this figurative and literal use; for depend upon it, the more laws you accept, the fewer penalties you will have to endure, and the fewer punishments to enforce. For wise laws and just restraints are to a noble nation not chains, but chain mail – strength and defence, though something also of an incumbrance. And this necessity of restraint, remember, is just as honourable to man as the necessity of labour. You hear every day greater numbers

of foolish people speaking about liberty, as if it were such an honourable thing: so far from being that, it is on the whole, and in the broadest sense, dishonourable, and an attribute of the lower creatures. No human being, however great, or powerful, was ever so free as a fish. There is always something that he must, or must not do; while the fish may do whatever he likes. All the kingdoms of the world put together are not half so large as the sea, and all the railroads and wheels that ever were, or will be, invented are not so easy as fins. You will find on fairly thinking of it, that it is his Restraint which is honourable to man, not his Liberty; and, what is more, it is restraint which is honourable even in the lower animals. A butterfly is much more free than a bee; but you honour the bee more, just because it is subject to certain laws which fit it for orderly function in bee society. And throughout the world, of the two abstract things, liberty and restraint, restraint is always the more honourable. It is true, indeed, that in these and all other matters you never can reason finally from the abstraction, for both liberty and restraint are good when they are nobly chosen, and both are bad when they are basely chosen; but of the two, I repeat, it is restraint which characterizes the higher creature, and betters the lower creature: and, from the ministering of the archangel to the labour of the insect, – from the poising of the planets to the gravitation of a grain of dust, – the power and glory of all creatures, and all matter, consist in their obedience, not in their freedom. The Sun has no liberty – a dead leaf has much. The dust of which you are formed has no liberty. Its liberty will come – with its corruption.

And, therefore, I say boldly, though it seems a strange thing to say in England, that as the first power of a nation consists in knowing how to guide the Plough, its second power consists in knowing how to wear the Fetter: –

(3) THE SWORD. – And its third power, which perfects it as a nation, consists in knowing how to wield the sword, so that the three talismans of national existence are expressed in these three short words – Labour, Law, and Courage.

This last virtue we at least possess; and all that is to be alleged against us is that we do not honour it enough. I do not mean honour by acknowledgment of service, though sometimes we are slow in doing even that. But we do not honour it enough in consistent regard to the lives and souls of our soldiers. How wantonly we have wasted their lives you have seen lately in the reports of their mortality by disease, which a little care and science might have prevented; but we regard their souls less than their lives, by keeping them in ignorance and idleness, and regarding them merely as instruments of battle. The argument brought forward for the maintenance of a standing army usually refers only to expediency in the case of unexpected war, whereas, one of the chief reasons for the maintenance of an army is the advantage of the military system as a method of education. The most fiery and headstrong, who are often also the most gifted and generous of your youths, have always a tendency both in the lower and upper classes to offer themselves for your soldiers: others, weak and unserviceable in the civil capacity, are tempted or entrapped into the army in a fortunate hour for them: out of this fiery or uncouth

material, it is only soldier's discipline which can bring the full value and power. Even at present, by mere force of order and authority, the army is the salvation of myriads; and men who, under other circumstances, would have sunk into lethargy or dissipation, are redeemed into noble life by a service which at once summons and directs their energies. How much more than this, military education is capable of doing, you will find only when you make it education indeed. We have no excuse for leaving our private soldiers at their present level of ignorance and want of refinement, for we shall invariably find that, both among officers and men, the gentlest and best informed are the bravest; still less have we excuse for diminishing our army, either in the present state of political events, or, as I believe, in any other conjunction of them that for many a year will be possible in this world.

You may, perhaps, be surprised at my saying this; perhaps surprised at my implying that war itself can be right, or necessary, or noble at all. Nor do I speak of all war as necessary, nor of all war as noble. Both peace and war are noble or ignoble according to their kind and occasion. No man has a profounder sense of the horror and guilt of ignoble war than I have: I have personally seen its effects, upon nations, of unmitigated evil, on soul and body, with perhaps as much pity, and as much bitterness of indignation, as any of those whom you will hear continually declaiming in the cause of peace. But peace may be sought in two ways. One way is as Gideon sought it, when he built his altar in Ophrah, naming it, 'God send peace,' yet sought this peace that he loved, as

he was ordered to seek it, and the peace was sent, in God's way: – 'the country was in quietness forty years in the days of Gideon.' And the other way of seeking peace is as Menahem sought it, when he gave the King of Assyria a thousand talents of silver, that 'his hand might be with him.' That is, you may either win your peace, or buy it: – win it, by resistance to evil; – buy it, by compromise with evil. You may buy your peace, with silenced consciences; – you may buy it, with broken vows, – buy it, with lying words, – buy it, with base connivances, – buy it, with the blood of the slain, and the cry of the captive, and the silence of lost souls – over hemispheres of the earth, while you sit smiling at your serene hearths, lisping comfortable prayers evening and morning, and counting your pretty Protestant beads (which are flat, and of gold, instead of round, and of ebony, as the monks' ones were), and so mutter continually to yourselves, 'Peace, peace,' when there is No peace; but only captivity and death, for you, as well as for those you leave unsaved; – and yours darker than theirs.

I cannot utter to you what I would in this matter; we all see too dimly, as yet, what our great world-duties are, to allow any of us to try to outline their enlarging shadows. But think over what I *have* said; and as you return to your quiet homes to-night, reflect that their peace was not won for you by your own hands, but by theirs who long ago jeoparded their lives for you, their children; and remember that neither this inherited peace, nor any other, can be kept, but through the same jeopardy. No peace was ever won from Fate by subterfuge

or agreement; no peace is ever in store for any of us, but that which we shall win by victory over shame or sin; – victory over the sin that oppresses, as well as over that which corrupts. For many a year to come, the sword of every righteous nation must be whetted to save or to subdue; nor will it be by patience of others' suffering, but by the offering of your own, that you will ever draw nearer to the time when the great change shall pass upon the iron of the earth; – when men shall beat their swords into ploughshares, and their spears into pruning-hooks; neither shall they learn war any more.